LEGENDARY LOCALS

—— OF ——

NEWPORT

RHODE ISLAND

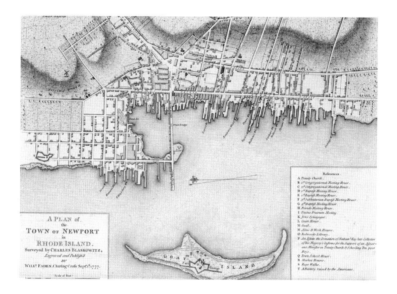

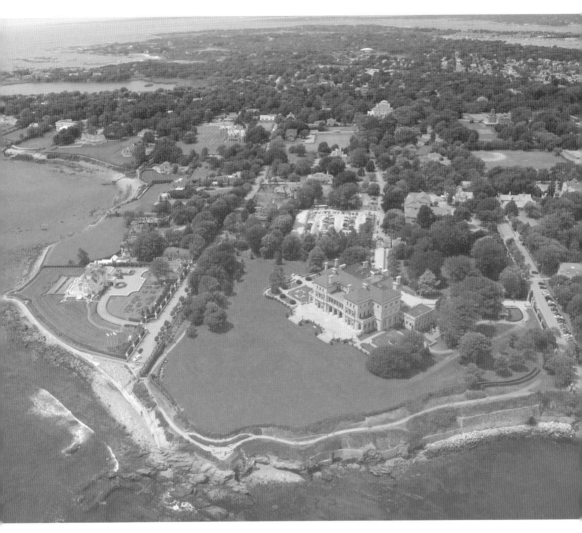

The Cliff Walk

Newport's Cliff Walk is the city's most popular attraction, drawing nearly a million visitors annually. The 3.5-mile path starts at Easton's Beach and skirts the cliffs behind the Bellevue Avenue mansions. (Photograph by Dave Hansen, courtesy of *The Newport Daily News*.)

Page 1: Newport, 1777

This map of Newport in 1777 shows the fledgling city while it was expanding into a bustling trading port. Featured here are Long and Bannister's Wharves, as well as Spring, Thames, and Farewell Streets, which are still the thoroughfares of Newport today. (Courtesy of the Newport Historical Society.)

LEGENDARY LOCALS
OF
NEWPORT
RHODE ISLAND

ANNIE SHERMAN

LEGENDARY
LOCALS

Legendary Locals is an imprint of Arcadia Publishing
Charleston, South Carolina

Printed in the United States of America

Library of Congress Control Number: 2013936819

For all general information, please contact Arcadia Publishing:
Telephone 843-853-2070
Fax 843-853-0044
E-mail sales@arcadiapublishing.com
For customer service and orders:
Toll-Free 1-888-313-2665

Visit us on the Internet at www.arcadiapublishing.com

Dedication
This book is dedicated to Derek Luke, the best husband, photography assistant, and cheerleader a girl could hope for.

On the Front Cover: Clockwise from top left:
Doris Duke at Rough Point (Courtesy of Doris Duke Photograph Collection, Doris Duke Charitable Foundation Historical Archives, David M. Rubenstein Rare Book & Manuscript Library, Duke University; see pages 50–51), Newport Artillery Company and cannon salute (Courtesy of Col. Robert Edenbach; see pages 38–39), Terry Moy and Apollo 17 landing (Courtesy of Terry Moy; see page 45), George Mendonsa and his famed *LIFE* magazine cover (Photograph by Ron Cowie, courtesy of *Newport Life Magazine*; see page 44), Elizabeth Meyer and *Coronet* (Photograph by Onne van der Wal; see page 58), Judge Florence K. Murray at her Newport County Courthouse (Courtesy of *The Newport Daily News*; see page 68), George Wein at his Newport Folk Festival (Photograph by Dave Hansen, courtesy of *The Newport Daily News*; see page 108), Maud Howe Elliott (Photograph by Bachrach, courtesy of Newport Art Museum Archives; see page 95), Paul Gaines (Courtesy of Paul Gaines; see pages 70–71).

On the Back Cover: From left to right:
John "Fud" Benson and son Nick Benson in their John Stevens Shop (Courtesy of Nick Benson; see page 99), Dr. Mark P. Malkovich III with Newport Music Festival performers and his children (Courtesy of Mark Malkovich IV; see page 67).

CONTENTS

ACKNOWLEDGMENTS

This book is possible thanks to help from these friends: Sheila Mullowney, Dave Hansen, Jacqueline Marque, Meredith Brower, and Anne Ewing, of *The Newport Daily News* and *Newport Life Magazine*; Ruth Taylor, Jennifer Robinson, Bert Lippincott, and the Newport Historical Society; Andrea Carneiro, Caitlin Emery, and The Preservation Society of Newport County; Jeanine Kober and the Newport Restoration Foundation; Julie Swierczek and Salve Regina University; Meredith Miller and the International Tennis Hall of Fame & Museum; Nancy Whipple Grinnell and the Newport Art Museum; Peggy O'Keefe and Newport Hospital; Prof. John Hattendorf and the Naval War College Museum; Maria Bernier, Robert Kelly, Whitney Pape, and the Redwood Library and Athenaeum; Newport Gulls; Newport Distilling Company; Brick Alley Pub & Restaurant; Kathryn Whitney Lucey; Cory Silken; Onne van der Wal; Sandy Nesbitt; Daniel Forster; Lane DuPont; Ron Cowie; Billy Black; Andrea Hansen; Rita Sciarrotta; Mark Malkovich IV; Daniel Jones; Dave Narcizo; Benny Smith; Harle Tinney; the Panaggio family; the Betty Hutton Estate; the Edith Wharton Estate; Elaine Lembo; Frances Sherman; and Jocelyn and Buck Sherman.

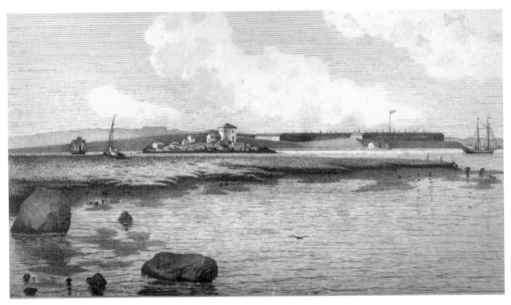

Fort Adams

The original fortification at the mouth of Narragansett Bay, seen at right in the background, was built by Newport residents in 1799, then rebuilt from 1824 to 1857 and renamed Fort Adams. Made of local shale and Maine granite, it is the largest coastal fortification in the country due to its manpower and weaponry, and was an active military fort through World War II. "It is the most sophisticated in land defenses, with ditches, tunnels and other defensive technologies, is one of the longest in use, and today, is one of the most complete, with its outerworks still intact," said Fort Adams Trust executive director Rick Nagele. "The guns of the main fortress never fired against the enemy, but it was active for training and supply of American troops." In the 1960s it was converted into Fort Adams State Park, and is now managed by the non-profit organization Fort Adams Trust. (Courtesy of *The Newport Daily News*.)

INTRODUCTION

Trekking through the Common Burying Ground in Newport, Rhode Island, I embark on a treasure hunt of legendary locals. At every turn is a disintegrating gravestone, softened by centuries of weather and sunken into the earth. Though worn, they still bear the carved names that are synonymous with Newport: Clarke, Coddington, Hazard, Easton, Belmont, Perry, and my obvious favorite, Sherman. Many were likely carved by the local stonemason of the time, John Stevens, whose successors, the Bensons, are featured on page 99. Even the cemetery's winding streets were named after the city's founding fathers, as they likely were the ones to plot it.

Another famous name, Ida Lewis, had initially attracted my husband and me to this historic cemetery in search of her final resting place among the 31 acres of household names. But before we found Newport's darling heroine and photographed her impressive gravestone (see page 37), we stumbled upon my ancestors. Three Annie Shermans, two Elizabeth Shermans, and at least a dozen other relatives were buried in the 17th- and 18th-century family plot. Some shared a massive gravestone with their spouse or sibling, next to their parents, grandfather, or great-uncle. Some stones showed amazing durability and strength despite their age. Others were crumbling. Through past research, I had known of the family's generations of venerable work as bankers, doctors, publishers, and dry goods dealers (see page 74) but not where they were buried. So I was pleasantly surprised that this seemingly simple mission to photograph Lewis's grave for this book had morphed into an education in my own family tree. Had Philip not come to Newport nearly 400 years ago, and had Job, Samson, Edward, and Albert not stayed here, I might have been born in England, or not at all, and I certainly would not have written this book.

Lessons like this are common here, with living history within arm's reach of generations of Newporters. Mine is among many founding families that still live and work in this "City by the Sea." In fact, the Newport Historical Society has hanging on its wall a modern certificate of the Newport Compact, signed by descendants of the original founders on the city's 250th anniversary in 1989. Nearly every one of the families is still living in the area and continues the traditions of hard work and perseverance set by their ancestors.

Newport was established on April 28, 1639, by nine men (see page 11); they arrived with their families from England via the Massachusetts Bay Colony, seeking religious, political, and social liberty. Tired of the oppression and bigotry they suffered in England, they traveled with Puritan Anne Hutchinson (see page 11) and others to establish nearby Pocasset (now Portsmouth) in 1638. But they grew restless, and as the settlement grew, the government fought to establish power in a fledgling democracy, alienating those who stood in its way. Within a year, the families that originally sought freedom there faced similar subjugation again, and so they secretly planned an exodus. Two days after the nine men signed the Newport Compact, Nicholas Easton, one of the founders who built the first houses in Pocasset and Newport, ventured around Aquidneck Island by land and sea with his teenage sons Peter and John. They discovered undeveloped land to the south that offered prime water access for trade activity, as well as a blank canvas on which to farm and create a peaceful community of like-minded Quakers and Baptists. There also was no one there telling them what to do, which allowed them to pray and politick as they pleased. Additional founders and families William Coddington, the judge in Pocasset and later governor of Aquidneck Island; clerk William Dyer; Baptist minister Dr. John Clarke (see page 12); and others soon followed, including my ancestor Philip Sherman (see page 74), who later became secretary under Governor Coddington.

The state's success on a grand scale was linked directly to the perseverance of its determined and open-minded residents. In the newly formed State of Rhode Island and Providence Plantations, Aquidneck Island was "the State of Rhode Island," while the rest of the state was considered "Providence Plantations." Heads of government ruled from a small wooden building in Newport, starting in 1687 until 1739, when it was

replaced by the more noble brick Colony House. It was used until 1901, when the state capital transferred permanently to Providence, after which it continued to be used as a courthouse. The building is the fourth oldest statehouse in the country and was situated conveniently at the head of the Parade, now Washington Square, where colonists would gather to socialize and pray. Leaders often conducted political business from the nearby White Horse Inn (1673), now the oldest continuously operating tavern in the country.

At the time, religious leaders regularly directed government affairs, as formalized separation of church and state was considered abominable. Most colonists believed that strict religious balance was the only way to maintain societal order. Examples include traditionalists William Coddington and Nicholas Easton, who clung to proven values for their own gain. But there was a new objective on the horizon. Progressive and liberal thinkers, like Dr. John Clarke and Providence founder Roger Williams, welcomed nonbelievers and encouraged diversity to forge a new social system of openness and acceptance. Not surprisingly, this test led to a little chaos, as religious and political leaders fought for control much like in Pocasset in 1638. But as the settlement grew into a colony with construction, development, local business, and trade by the early 18th century, there was more opportunity than ever before. Clarke was long buried by then, but his "lively experiment" worked, as set forth in his Royal Charter of 1663 ratified by England's King Charles II. The community's political and social acceptance extended toward additional settlers with European backgrounds, but not to the Native Indians. Though they took advice on farming and adapting to the harsh New England weather, the colonists sought to take complete control of their new island nation and evict the natives.

With the addition of small wharves on the waterfront and spurred by active farmers and maritime tradesmen like shipbuilders, rope makers, and carpenters, international business boomed for nearly a century. By 1708, export exceeded 20,000 pounds, primarily to the West Indies thanks to the triangular trade: Caribbean slaves produced molasses and sugar that was carried to Newport and made into rum. The rum was sent to Africa to trade for slaves, who were sent to the Caribbean to make more molasses. The city and state were pivotal in the slavery trade, transporting roughly 100,000 slaves on local ships, while many well-known local merchants made riches in human trafficking. Though there were more slaves here per capita than any other New England state, Rhode Island passed a law abolishing African slavery in

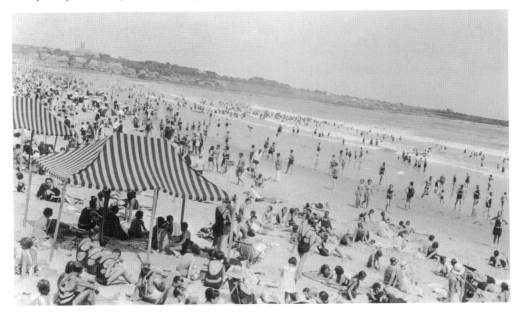

Easton's Beach
Easton's Beach was the place to be seen, and bathers took full advantage. A scenic railway park, including a Ferris wheel on the boardwalk, was later washed away during the Hurricane of 1938. (Courtesy of Benny Smith.)

1652. Many local property owners preferred Caucasian servants, however, and those Africans here before the American Revolution were domestic or worked in distilleries and the marine trades. Most even lived in the same home as their owners, took their name, and practiced their religion, while approximately 300 black Africans were buried near their owners in the Common Burying Ground, in what is known as God's Little Acre.

By 1720, Newport was one of the top five major colonial towns, with Boston, Philadelphia, New York, and Charleston, with a population of nearly 2,500. With the success of shipping here, piracy was rampant, too, and Newport's own Thomas Tew (see page 31) made a name for himself from the Caribbean to the Red Sea. Success was short-lived, however, as Newport's commercial dominance came to a close with the Revolutionary War in 1775. Even the local newspaper *Newport Mercury*, published by Solomon Southwick, was shuttered. When many Newporters were called to battle or were forced to abandon their homesteads and businesses for safe ground along with the rest of their New England neighbors, Solomon Southwick, son-in-law to Ann Franklin (see page 30), buried the printing press. Once the British left Newport, he returned and resumed printing. But the city's trading reputation never recovered, despite the resilience of those who returned. Since then, Newport has been known for the strength of its small businesses, as it was when originally founded, rather than its sizeable industry.

Thankfully the ports remained the city's heartbeat, and by 1800, Newport and its resistant people played a pivotal role during the burgeoning Industrial Revolution. As Newport's original founders predicted, access to the water for shipping was a key component to the city's success. Steamships quickly dotted the wharves, bringing with them new visitors from the mainland that was once considered an extreme distance to travel by ferry or horse and carriage. By the end of the 19th century, those steamships helped usher in the Gilded Age era of opulence, and families like the Vanderbilts (see pages 26–28), Wetmores (see pages 24–25), and Kings (see pages 22–23) chose Newport as their summer playground, with extravagant mansions along the new Bellevue Avenue. It was such a paradox to Newport's past; construction in the colonial era was limited to homesteads and small businesses, with undersized rooms to maximize heat and

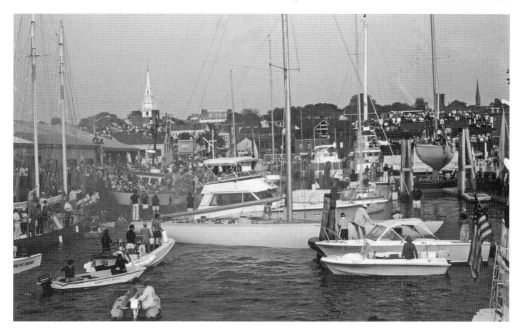

Bannister's Wharf, September 1983
The America's Cup was a major influence here. Races were sailed in the waters off Newport from 1930 until 1983. This scene ensued when the yachts returned to Bannister's Wharf after the New York Yacht Club's *Liberty* lost to challenger *Australia II*. (Courtesy of Daniel Forster.)

small plots of land dedicated to growing what the family needed to eat. The large farmland that originally attracted settlers here had been subdivided as the community grew. As a result, Newport is now known to have the largest concentration of existing colonial buildings in the country. Conversely, architecture of the Gilded Age was an altogether different beast, with architects like Richard Morris Hunt (see page 19) commissioned to design impervious palaces of marble behind elaborate gates, where wealthy barons would entertain the world's elite. No consideration was given to modesty, affordability, or work of any kind. Nor was any expense spared. Newport had become a showpiece of grandeur to the rest of the world.

In addition to their lavish lifestyles here, these gilded families traveled the world looking for the best of everything. They brought back precious antique furniture and art, silver, fabrics, clothing, jewels, and other items that remain on display in Newport today. Their collections were not limited to indoors, however, as they also returned with valuable flora and fauna to plant in their vast yards, including collections of European beech trees, from copper and green to the weeping variety. As a result, many private properties and city streets here are replete with these gigantic arbors—in fact, Newport is known worldwide to have one of the rarest collections of foreign tree species. It helped, too, that some hired famed landscape architect Frederick Law Olmsted in the late 1800s, and he further incorporated these beauties into the local landscape.

Behind the hedgerows of sophisticated mansions, the regular Newport businessman continued his work, instilling the elemental foundations of modernity and convenience of the mid- to late 19th century. Newport Hospital was built thanks to the dedication of people like founder and first president Henry Ledyard (see page 18). The Naval War College was established here, and later Naval Station Newport, taking advantage of centuries of naval prowess, while historians Alfred Thayer Mahan (see page 34) and Prof. John Hattendorf (see page 35) continued the education of officers. Even local George Henry Norman (see page 62) helped create the city's public water system and helped found *The Newport Daily News* on May 4, 1846. It is still the city's only daily newspaper and has been owned and operated by my family (see page 74) since 1918.

With the extraordinary history, architecture, and people that have shaped Newport's past, preservation has become equally important to recognizing and saving that history. In the 20th century, preservationists played a key role in rescuing homes and businesses, documents, and even boats, furniture, and clothing. A precious few have been responsible for so much critical conservation here when it was not considered de rigueur. The city would be a shell of its former self without their careful foresight. Organizations like The Preservation Society of Newport County, the Newport Restoration Foundation, and the International Yacht Restoration School, which shared many images and facts for this book, were founded by, respectively, thoughtful legendary locals like Katherine Warren (see page 52), Doris Duke (see page 50–51), and Elizabeth Meyer (see page 58).

Of course, in addition to protecting its past, the city could not leap into the future without development and careful consideration of what it needs as a modern city. Construction of the Newport Bridge, with Francis "Gerry" Dwyer (see page 56) at the helm, and Bill Leys's (see page 57) Newport Redevelopment Agency were two key endeavors that helped the entire island community move into the 21st century. With a front door to the mainland and access to the waterfront, tourism is now the city's institution, with more than a million visitors annually. They come for the mansions, beaches, waterfront shopping, restaurants, and activities, as well as the famous Cliff Walk, offering a back-door view into the homes of Bellevue Avenue's elite. Even local artwork is an attraction, with painters, photographers, sculptors, jewelers, authors, actors, journalists, musicians, and film producers using this community as their inspirational muse (see page 89).

With Newport celebrating its 375th anniversary in 2014, what better time to respect where the city has come from and plan where it is going. While there are so many deserving, significant, and inspiring souls who have made Newport such an enduring home, destination, and historic US waypoint, it was impossible to include every one of them in this book. Because the community is so colorful, it was both a blessing and a curse to select the legends featured here. I received a great education in our city's story, including the one forged by my own family, and I hope you do as well. Ultimately, the fundamental beliefs on which the city was founded still exist today as it continues to be a melting pot of social values, localism, and legends. I am honored to share with you a brief glimpse into our passions, inspiration, and perseverance.

CHAPTER ONE

Founders and the Gilded Age

The city's founders were religious freedom seekers who arrived in the early 17th century from the Massachusetts Bay Colony. Puritan activist and midwife Anne Hutchinson (1591–1643) had been excommunicated and banished, and so she headed south with her husband, William, and 15 children. Encouraged by English Protestant theologian Roger Williams (1603–1683), who founded Providence, the Hutchinsons established the settlement of Pocasset (now Portsmouth) with Baptist minister Dr. John Clarke (1609–1676), purchasing Aquidneck Island from the Indians in 1638. Leaving Portsmouth to settle Newport to the south, Dr. John Clarke, William Brenton, Henry Bull, Jeremy Clarke, William Coddington, John Coggeshall, William Dyer, Nicholas Easton, and Thomas Hazard signed the city's compact in 1639. Clarke authored the charter when these two settlements combined to become the Colony of Rhode Island and Providence Plantations in 1663. As early as 1658, Jewish settlers also sought refuge here. Dutchman Isaac Touro came a century later to spiritually guide the city's Yeshuat Israel congregation. It still thrives today at Touro Synagogue, which celebrated its 250th anniversary in 2013. As a permanent reminder of the founders' sacrifices, their names are prominent here, gracing streets, businesses, beaches, a school, a state park, and the oldest synagogue in the country.

The city's founding did not end there, however, as colonists continued to define Newport and how it became known around the world. Given its prime spot at the mouth of Narragansett Bay, it was a magnet for international trade and politics in the 18th century, so when the Civil War ended, it was no surprise that wealthy businessmen started spending millions of their untaxed dollars here. With the advent of the Gilded Age and the second Industrial Revolution, famous families including the Vanderbilts, Wetmores, and Kings chose Newport as their playground, building shrines to their success that still amaze. Even the architects who designed their palaces became world-renowned for their work here, including Richard Morris Hunt and the firm of McKim, Mead & White. More legends in this chapter will showcase the foundation upon which Newport was built.

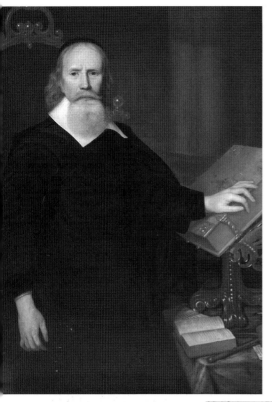

Dr. John Clarke

This English-born minister and statesman is generally considered the founder of the Baptist faith in America. But this pioneer of religious freedom (1609–1676) made history by purchasing Aquidneck Island from the Native Indians, establishing the Portsmouth settlement in 1638 with Puritan activist Anne Hutchinson, and Newport in 1639 with eight others: William Brenton, Henry Bull, Jeremy Clarke, William Coddington, John Coggeshall, William Dyer, Nicholas Easton, and Thomas Hazard. Clarke authored the Charter of Rhode Island in 1663, securing "the Colony of Rhode Island and Providence Plantations." According to Redwood Library and Athenaeum, he is said to have written his will on his deathbed, which stipulated the creation of an educational trust fund "for the relief of the poor or bringing up of children unto learning from time to time forever." The John Clarke Fund is now the oldest educational trust in the country; the Newport Historical Society possesses this original document, seen below. At left, "Portrait of a Clergyman" by Guilliam de Ville, around 1659, is said to show Clarke and hangs in the Redwood Library and Athenaeum. He is buried at the Common Burying Ground in Newport. (Left, courtesy of the Redwood Library and Athenaeum; below, courtesy of the Newport Historical Society.)

Peter Harrison

An English-born architect, Harrison (1716–1775) immigrated to Rhode Island in 1740 where he designed some of Newport's best-known structures, which became some of the country's most architecturally significant buildings because of their classical style. His first commission, Redwood Library (1750), pictured below, is the oldest library building in continuous use in the country. He designed Touro Synagogue in 1763 (see page 14), which faces east toward Jerusalem. Legends abound about the trap door beneath the tebah that was said to be used while the synagogue was a stop on the Underground Railroad. Both of these buildings are listed in the National Register of Historic Places, as is his third Newport design, the Brick Market (1762), which is now the Museum of Newport History. (Right, courtesy of the Redwood Library and Athenaeum; below, photograph by Annie Sherman.)

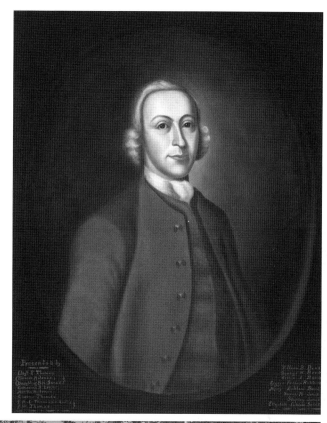

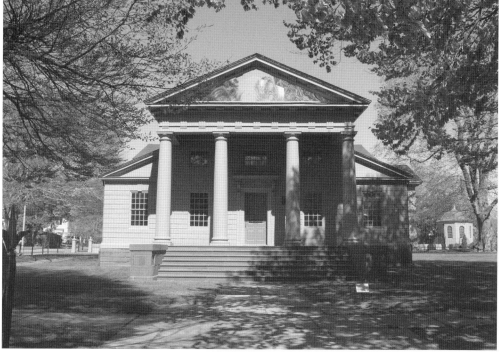

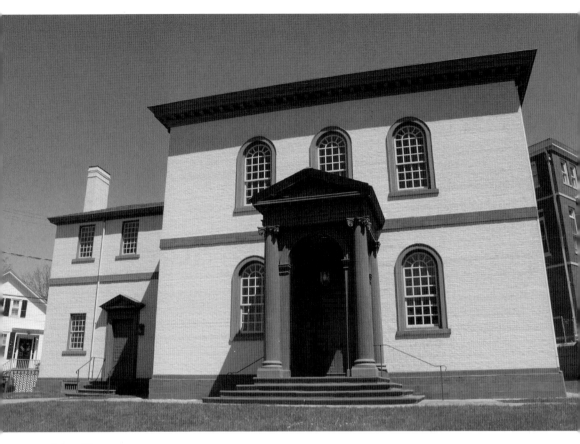

Isaac Touro
A native of Holland, Touro (1738–1783) came to Newport and, in 1758, became rabbi of the country's oldest congregation of Sephardic Jews, Yeshuat Israel, assembled in 1658. He led them in building a permanent synagogue, designed by Peter Harrison in 1763, seen here. During the American Revolution, most Jewish families fled Newport, but Touro remained to protect the synagogue while it was used as a British hospital. (Photograph by Annie Sherman.)

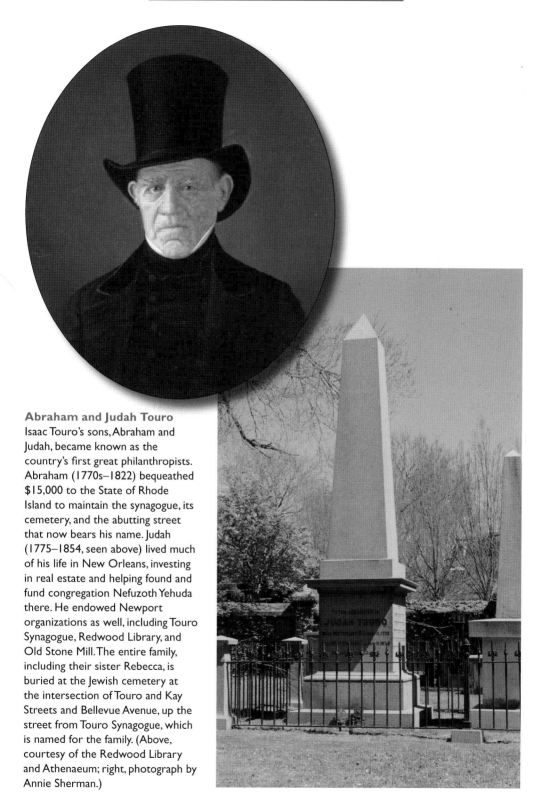

Abraham and Judah Touro
Isaac Touro's sons, Abraham and Judah, became known as the country's first great philanthropists. Abraham (1770s–1822) bequeathed $15,000 to the State of Rhode Island to maintain the synagogue, its cemetery, and the abutting street that now bears his name. Judah (1775–1854, seen above) lived much of his life in New Orleans, investing in real estate and helping found and fund congregation Nefuzoth Yehuda there. He endowed Newport organizations as well, including Touro Synagogue, Redwood Library, and Old Stone Mill. The entire family, including their sister Rebecca, is buried at the Jewish cemetery at the intersection of Touro and Kay Streets and Bellevue Avenue, up the street from Touro Synagogue, which is named for the family. (Above, courtesy of the Redwood Library and Athenaeum; right, photograph by Annie Sherman.)

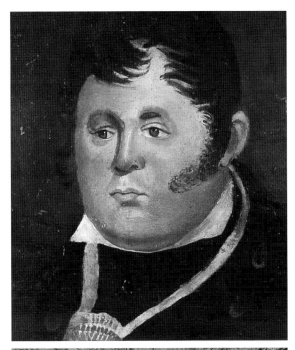

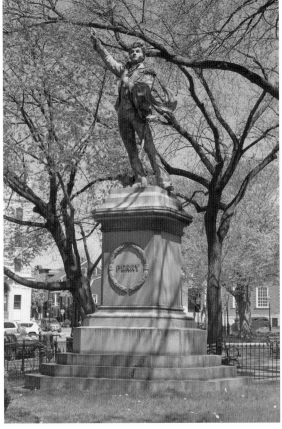

Commodore Oliver Hazard Perry
One of the early US Navy's greatest heroes, the South Kingstown–born Perry (1785–1819) lived on Thames Street in Newport with his wife, Elizabeth Champlin Mason. Known for his decisive victory in the Battle of Lake Erie during the War of 1812, he switched ships mid-battle, abandoning the destroyed *Lawrence* in favor of *Niagara* to defeat the British fleet. Neither of those feats had ever been accomplished. His message to Gen. William Henry Harrison, who later became president, read, "We have met the enemy and they are ours." Six years later, he died of yellow fever on a mission in South America; shortly prior to his death, his wife was said to have dreamed his death, according to Redwood Library and Athenaeum. He was buried in Trinidad, dug up twice, and is now interred in Island Cemetery in Newport. The portrait above was originally painted on the floorboards of his home; his statue is in Washington Square. (Top, courtesy of the Newport Historical Society; bottom, photograph by Annie Sherman.)

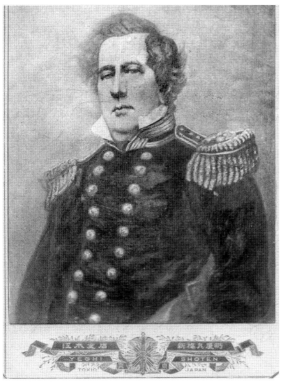

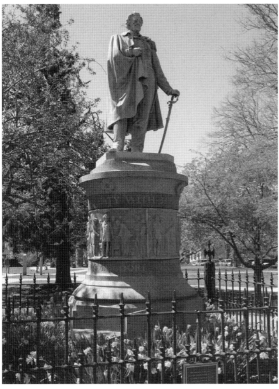

Matthew Calbraith Perry
The younger brother of Oliver Hazard Perry, Matthew Calbraith Perry (1794–1858) had his own naval success. Most significantly, he was responsible for negotiating the Treaty of Kanagawa in 1854 that established trade and diplomatic relations with Japan, which had endured two centuries of self-imposed isolation from the rest of the world. When Perry arrived in Tokyo Bay to reach a deal, the Americans' "Black Ships" with no sails and spewing black smoke surprised the Japanese. In commemoration of Perry's accomplishment, the Black Ships Festival is celebrated every summer in Newport, and this statue of him stands in Touro Park where the festival's numerous activities occur. (Top, courtesy of the Newport Historical Society; bottom photograph by Annie Sherman.)

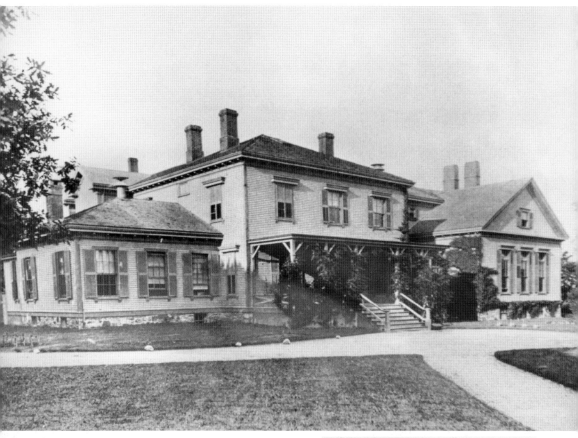

Henry Ledyard

Founder, fundraiser, and first president of Newport Hospital, Ledyard (1812–1880) was an astounding advocate for professional care during an era when the sick were treated at home. "Newport is so isolated from Providence," he said in 1873 when it was founded as a 12-bed cottage hospital on donated land, "particularly in winter, the distance and consequent loss of time before a patient can receive proper treatment exposes him to increased suffering and diminishes his chance of recovery." Though he spent the end of his life in Newport, Ledyard was born in New York City, and after graduating Columbia College in 1830, he worked at the American embassy in Paris. Returning to Michigan in 1844 with his wife and five children, he later became mayor of Detroit and state senator. His grave is in Newport's Common Burying Ground. (Above, courtesy of Newport Hospital; right, photograph by Annie Sherman.)

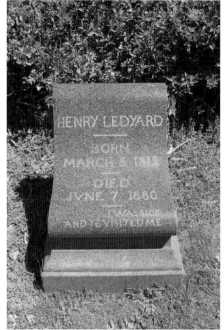

Richard Morris Hunt
The architect who designed The Breakers (1895) for Cornelius Vanderbilt II had already shaped Newport's, and the nation's, architectural heritage when he earned this commission. His design of Ochre Court (1892, seen below) for Ogden Goelet and Marble House (1892) for Vanderbilt's brother William K. not only secured his esteem but also his social stature in this wealthy resort town. Born in Vermont, Hunt (1827–1895) was the first American to study at L'Ecole des Beaux-Arts in Paris. His other local projects include the Newport Art Museum (1894) and Belcourt Castle (1894). While in New York City, he created the facade and Great Hall of the Metropolitan Museum of Art (1872) and the Statue of Liberty pedestal (1886). He also was part of a group that founded the American Institute of Architects. (Left, courtesy of the Newport Historical Society; below, photograph by Annie Sherman.)

James Gordon Bennett Jr.

In the summer of 1879, *New York Herald* publisher Bennett (1795–1892) bet friend Capt. Henry Augustus Candy to ride his polo horse onto the porch of the esteemed Newport Reading Room gentlemen's social club. According to the International Tennis Hall of Fame & Museum, Candy took the dare further and rode inside. The club revoked his guest privileges, and Bennett was so enraged, he left the club. He later purchased land along Bellevue Avenue to found the Newport Casino, which became the center of social activity for more than 40 years. The first US National Tennis Championships (now the US Open) were held there from 1881 to 1914. Now home to the International Tennis Hall of Fame & Museum, the facility was designated a National Historic Landmark in 1987. The Newport Reading Room is still a gentlemen's club. (Courtesy of the International Tennis Hall of Fame & Museum.)

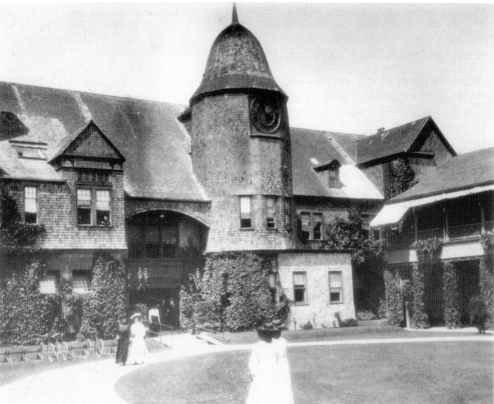

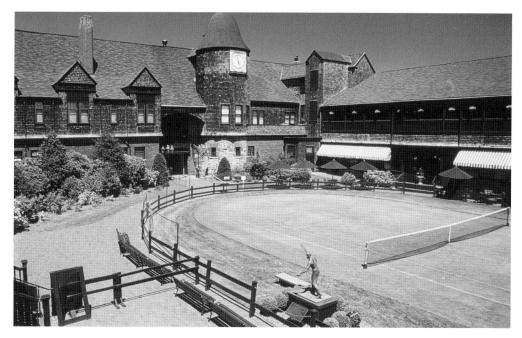

McKim, Mead & White

Considered among the best Shingle-style and Beaux-Arts architects of their time, the firm of Charles McKim (1847–1909), William Mead (1846–1928), and Stanford White (1853–1906) designed three prominent buildings along Bellevue Avenue. The first, Newport Casino (1880), seen above, was commissioned by James Gordon Bennett Jr. (see page 20). They designed the Isaac Bell House (1883) for wealthy cotton investor and broker Isaac Bell, creating an innovative combination of Old English and European architecture with colonial American and exotic details. Rosecliff (1902), seen below, for Nevada silver heiress Theresa Fair Oelrichs was based on the Grand Trianon at Versailles. They also designed the Narragansett Towers Casino (1883), Boston Public Library (1895), Rhode Island State House in Providence (1904), and New York's Penn Station (1910). (Above, photograph by Kathryn Whitney Lucey; below, courtesy of The Preservation Society of Newport County.)

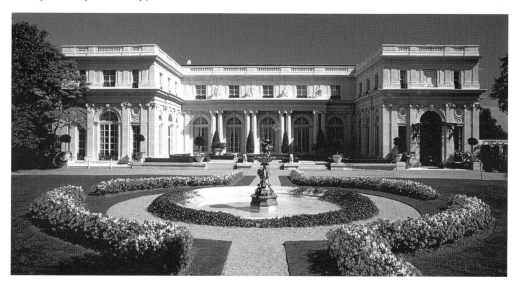

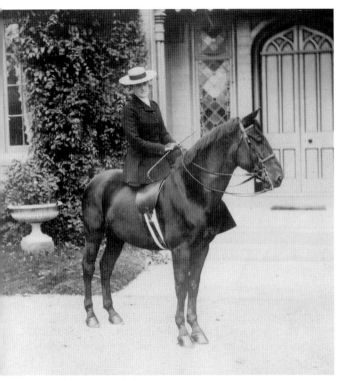

David and Ella King

The Kings were a seemingly more down-to-earth family than their Bellevue Avenue neighbors, yet they are still defined by their impressive houses. Dr. David King (1774–1836) was a respected physician here. His sons Edward and William became successful China traders. Edward L. King commissioned from architect Richard Upjohn an Italianate villa with views of the bustling port in 1845. Today, it is the Edward King Senior Center. William H. King (1818–1897) traveled extensively, collecting art and antiques. He purchased an estate, which became known as Kingscote (below), next door to his brother in 1863. When he suffered a mental collapse in 1866, the house was rented before 1875, when his nephew David King Jr. (1839–1894) moved in with wife, Ella (1851–1925, at left), and their two children. (Courtesy of The Preservation Society of Newport County.)

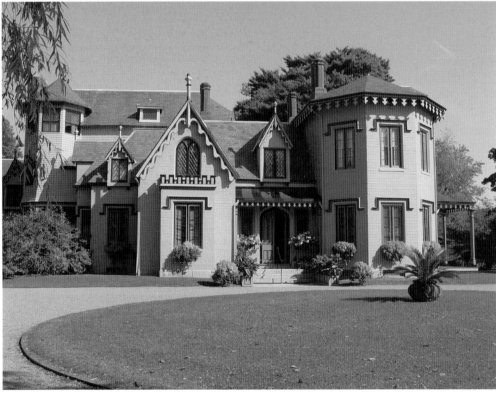

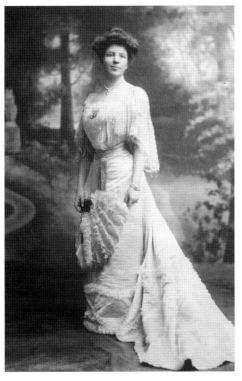

Two Gwendolen Kings
David and Ella King's daughter and granddaughter had a permanent influence on the landscape of Newport. Daughter Gwendolen (1876–1968, at left) married Edward M. Armstrong at Trinity Church in 1901, and when he died in 1915, she took her daughter, Gwendolen, and son, Edward Jr. (below right), to Kingscote (1841) to live with her mother. After Ella died in 1925, Gwendolen stayed at Kingscote and fought city government to protect the estate from demolition and development in the 1950s and 1960s. Her daughter, Gwendolen (1911–1972, below left), inherited her mother's advocacy for historic preservation and bequeathed Kingscote and all its furnishings to The Preservation Society of Newport County. It is now open to the public as a National Historic Landmark, flanked on two sides by shopping centers. (Courtesy of The Preservation Society of Newport County.)

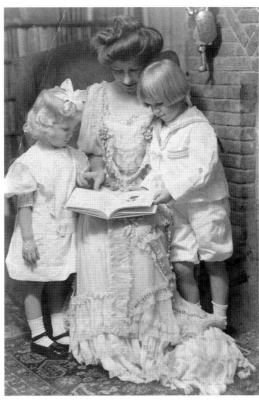

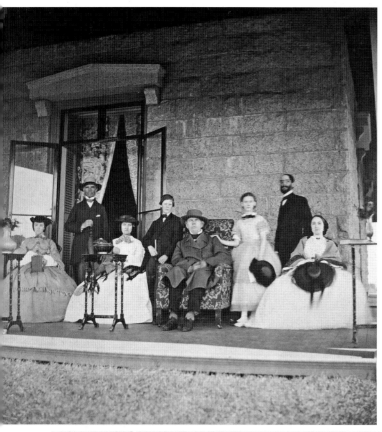

George Peabody Wetmore
George Peabody Wetmore (1846–1921) inherited his father's mercantile trade fortune, as well as his Bellevue Avenue estate, Chateau Sur Mer (1852), when William S. Wetmore died in 1862. Elected Rhode Island's governor in 1885, he served two terms and, in 1894, became a US senator. Though he traveled often for work, he was active in the lives of his four children and communicated with them regularly from afar, offering advice and discipline. Philanthropy and public service were family traits that he inherited from his father and passed to his children. He was instrumental in establishing the Army and Navy YMCA, fundraising for Newport Hospital, and the widening of Bath Road (now Memorial Boulevard). (Courtesy of The Preservation Society of Newport County.)

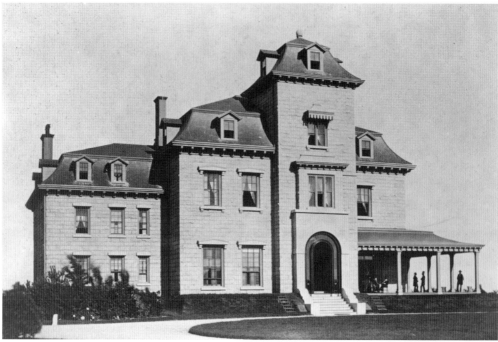

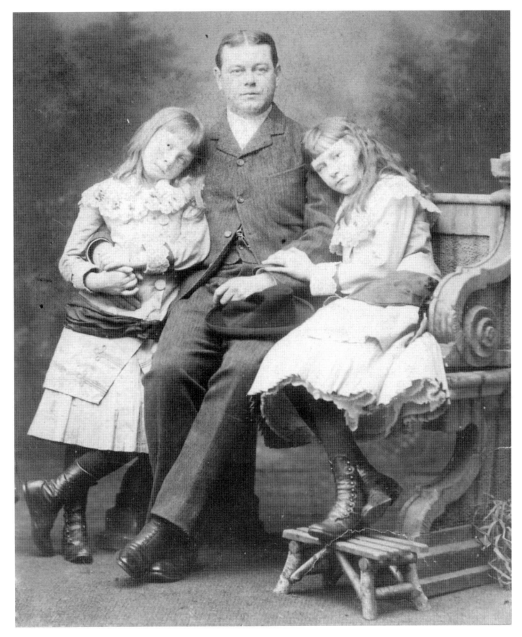

Edith and Maude Wetmore
George Peabody Wetmore's daughters, seen here with him in 1919, grew into hardworking philanthropists. Maude (1873–1951) was outspoken in state and national politics while older sister Edith (1870–1966) was active in architectural preservation. The two were among the founders of The Preservation Society of Newport County in 1945. In memory of their parents, the unmarried sisters donated funds and a harborfront building to the Seamen's Church Institute in 1930 (see page 53), which remains a haven for the less fortunate. (Courtesy of The Preservation Society of Newport County.)

Alva and William K. Vanderbilt
She came from Alabama with more pedigree than wealth, marrying into one of the country's richest 19th-century families. "I blazed the trail for the rest to walk in," she said. Alva (1853–1933) and William K. (1849–1920) summered in Newport at their opulent Marble House, which he presented to her as a 39th birthday present, complete with 500,000 cubic feet of marble. He was a fanatic horse breeder, owned the 1895 America's Cup winner *Defender*, and served on the board of the New York Central Railroad that his grandfather "Commodore" Cornelius Vanderbilt established and that his brother Cornelius II (see page 28) managed. The portrait below was painted in 1920. Alva, seen at right dressed for an 1883 ball, was a New York and Newport society hostess who championed the suffrage movement and founded the Political Equality League. They divorced in 1895 with a reported $10 million settlement. (Courtesy of The Preservation Society of Newport County.)

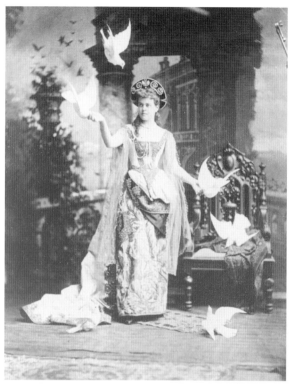

The Vanderbilt Life
Alva and William K. Vanderbilt are seen here aboard their yacht *Alva* cruising in Egypt in 1888, with their children and friend Oliver Hazard Perry Belmont. After Alva divorced William, she married Belmont and redecorated his house, Belcourt Castle (1894), down the street from her Marble House. "I don't believe in marriage," she said. "I never shall until we have true equality of the sexes." (Courtesy of The Preservation Society of Newport County.)

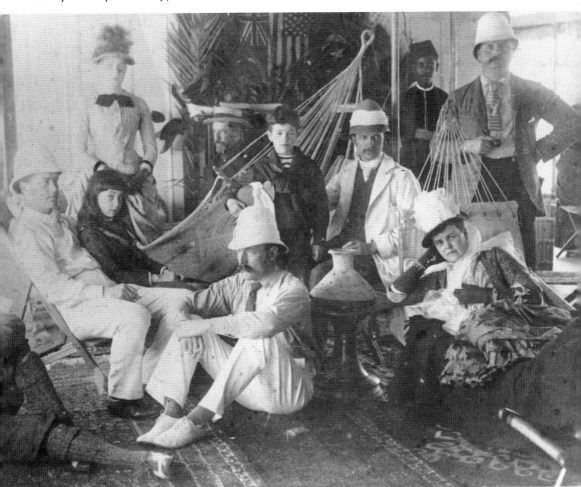

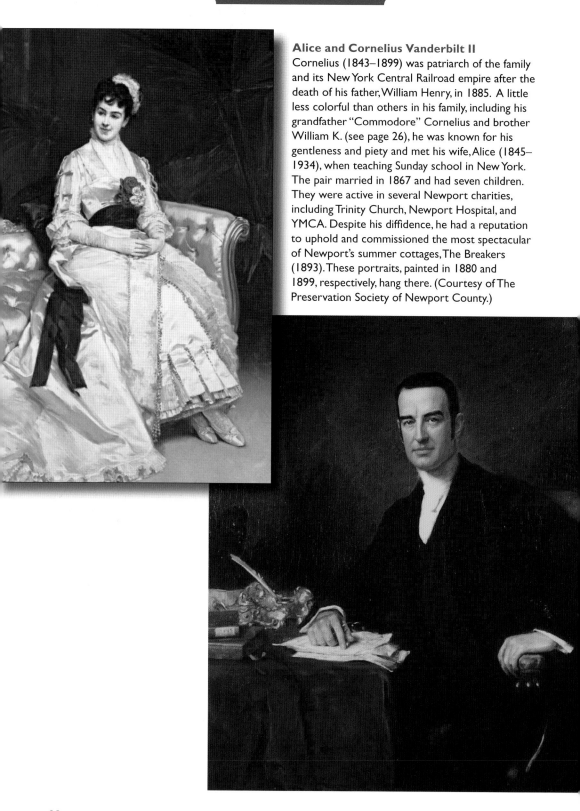

Alice and Cornelius Vanderbilt II
Cornelius (1843–1899) was patriarch of the family and its New York Central Railroad empire after the death of his father, William Henry, in 1885. A little less colorful than others in his family, including his grandfather "Commodore" Cornelius and brother William K. (see page 26), he was known for his gentleness and piety and met his wife, Alice (1845–1934), when teaching Sunday school in New York. The pair married in 1867 and had seven children. They were active in several Newport charities, including Trinity Church, Newport Hospital, and YMCA. Despite his diffidence, he had a reputation to uphold and commissioned the most spectacular of Newport's summer cottages, The Breakers (1893). These portraits, painted in 1880 and 1899, respectively, hang there. (Courtesy of The Preservation Society of Newport County.)

CHAPTER TWO

Locals and Revolutionaries

There is just something about Newporters; it is not just that they are hardworking, have won awards, or started movements. It is their energy and passion for what they do that warrants attention. Or sometimes, they just have a great story, evidenced in those included here. Whether they are a preeminent naval historian and strategist, a popular local fisherman, the first woman editor and printer in the country, the information architect, or "The Kissing Sailor," they do not necessarily fit anyone's standard classification. Or perhaps, they fit too many categories to pick just one. That is how the locals in this chapter came to be included. They are just legends.

As obscure as their taxonomy might be, their influence still is paramount to this city. Included is Prof. John Hattendorf, director of the US Naval War College Museum here. His mentor of sorts, Alfred Thayer Mahan, US Naval War College president in the 1880s and 1890s, established the US Navy's warfare strategy through sea power before anyone knew they needed it. Hattendorf even won the Alfred Thayer Mahan award for literary achievement. Then there is lobsterman Louis Jagschitz, who fished Newport waters his whole life. State Pier No. 9 is named in his honor, and he graced the cover of a book by local photojournalist Kathryn Whitney Lucey, who also contributed to this book. Ann Franklin married Benjamin Franklin's brother James and continued the family printing business here, printing paper currency, the *Almanac*, and the country's oldest newspaper, *Newport Mercury*, which still is published today. Finally, George Mendonsa kissed a nurse in Times Square when World War II ended, and *LIFE* magazine put the iconic moment on its cover. He has been known as "The Kissing Sailor" ever since.

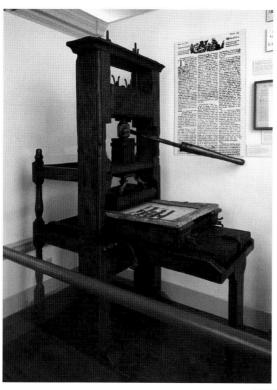

Ann Franklin

Franklin (1696–1763) was the country's first female newspaper editor and printer. When her husband James, Benjamin Franklin's brother, died in 1735, she inherited the printing business and continued to print with her five children, including an almanac and currency. In 1758, her son James started the nation's first newspaper, *Newport Mercury*, which is still printed today. When he died in 1762, Ann took over until her death the next year; her son-in-law Samuel Hall continued, selling to Solomon Southwick in 1768. When the British invaded Newport during the American Revolution, Southwick buried the press and fled, only to have it unearthed and used to print British war propaganda. After the war, in 1779, he returned to Newport and the press, and the *Mercury* once again hit the streets. The press is displayed at the Museum of Newport History, and this sample of their work is at the Newport Historical Society. (Courtesy of the Newport Historical Society.)

Thomas Tew

This pirate, grandson of Richard Tew of Newport, arrived in Bermuda in 1691. He bought a part-share in the sloop *Amity* and was ordered by Governor Richier to capture the French factory of Goree in western Africa. After surviving a storm mid-voyage, Captain Tew (1650–1695) reportedly convinced his crew to abandon their orders and become pirates. "A gold chain or a wooden leg – we'll stand by you," they shouted. Success on the high seas led them to a pirate's settlement near Madagascar run by Captain Mission, where Tew and crew lived like kings and slaves were treated as equals. He led many pirating conquests, bringing back more gold, jewels, and riches, even conquering a Portuguese navy flotilla, for which he was made admiral of the fleet. Later, Admiral Tew led a trading voyage back to America, landing in Newport where he was given a hero's welcome. He was content to settle there, but his crew had squandered its riches and was eager for adventures again. Tew acquiesced, received a privateering commission from friend and New York governor Benjamin Fletcher, and headed to Africa. At the mouth of the Red Sea, they joined the armada of pirate "Long Ben" Avery and engaged a fleet of Moorish ships. Tew apparently was shot in the stomach during battle, and "when he dropp'd, it struck such Terror in his men, that they suffered themselves to be taken, without making Resistance." Tew died that day, far from his comfortable Newport home. This symbol adorned his flag, and now graces bottles of Thomas Tew Rum distilled in Newport. (Courtesy of Newport Distilling Company.)

Dr. Marcus Fitzherbert Wheatland Born in Barbados, Wheatland (1868–1934) landed in Boston in 1887 looking for work. He came to Newport in 1894 after receiving his doctorate in medicine from Howard University. He became a well-respected physician here, operating his own practice for 40 years. He had the first x-ray machine in the city, and his authority in using it to diagnose ailments helped him become the country's first African American radiology specialist. His groundbreaking lecture on the value of the x-ray to the National Medical Association (NMA) in 1909 was the first documented presentation of its kind. He was elected NMA's 11th president the following year. West Broadway in Newport was renamed in his honor in 1994. (Courtesy of the Newport Historical Society.)

Dr. Benjamin Waterhouse

Born in Newport, Waterhouse (1754–1846) was a Quaker dedicated to defending his "iconoclastic and scientific ideas." Earning his medical degree in Scotland, he experimented with smallpox vaccinations in Boston, injecting his entire family and then exposing them to the virus. They remained healthy, and he was instrumental in establishing the vaccine's acceptance nationwide. (Courtesy of the Harvard Art Museums/Fogg Museum, Harvard University Portrait Collection, gift of Mrs. Benjamin Waterhouse to Harvard College, 1863.)

George Brian "Dr. Love" Sullivan

With a doctorate in English literature, this "Newportant" local is widely known as Doctor Love (1939 to present). He wears a beret, carries index cards to jot notes on anything that interests him, and is regularly seen about town at city events. He is passionate about civic responsibility, promoting social and community awareness, all in the name of love and community.

He said his "American Lovolution" initiative will help us know who we are and find happiness. His motto is: "For cares and affaires of the heart, consult Doctor Love." (Photograph by Jacqueline Marque, courtesy of *Newport Mercury*.)

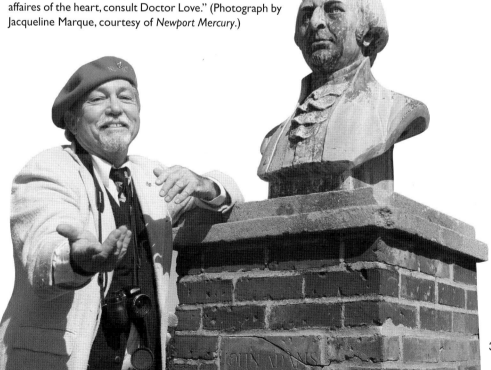

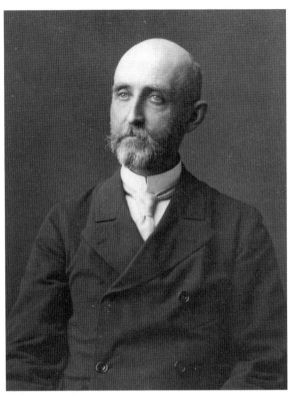

Alfred Thayer Mahan

The preeminent American naval strategist and historian, Mahan (1840–1914) was president of Newport's Naval War College from 1886 to 1889 and from 1892 to 1893. His Newport lectures were published as "The Influence of Sea Power upon History" (1890) and "The Influence of Sea Power upon the French Revolution and Empire" (1892), which transformed international naval thinking. "Mahan is one of the great historians in the field, and one of the most famous names related to the college," said Dr. John Hattendorf, Naval War College Museum director and winner of the Alfred Thayer Mahan Award for Literary Achievement (see page 35). "He was an intellectual leader in the Navy." Mahan instructed Naval students in the building that now is the museum, seen below in 1880, which was built in 1819 and originally was Newport's poorhouse for indigents. (Courtesy of the US Naval War College Museum.)

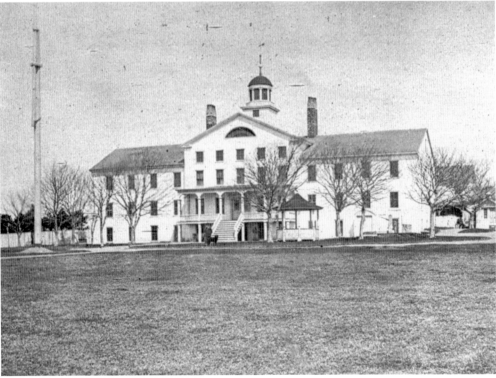

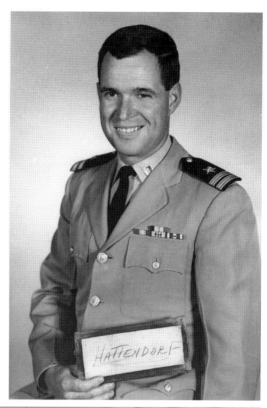

Prof. John Hattendorf
History was always his best subject. "I knew when I was 14 I would be a historian," Hattendorf said from his book-filled office at the Naval War College Museum. A career in naval history is perfect for Hattendorf (1941 to present), who is museum director and Ernest J. King Professor of Maritime History. He did not intend on a Navy career, but after eight years as an officer during the Vietnam War era, he was convinced to stay with the only assignment he would accept—the Naval History Division in Washington, DC. He returned as a civilian in 1977 to the college, and since then, he has authored or coauthored more than 40 books on British and American maritime history and naval warfare. "The Navy has tremendous heritage, and there is amazing insight that can come from past experience," he said. (Courtesy of the US Naval War College Museum.)

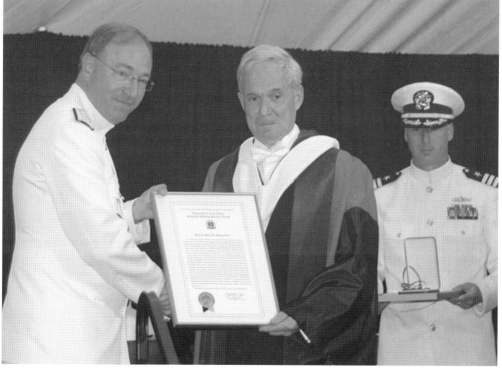

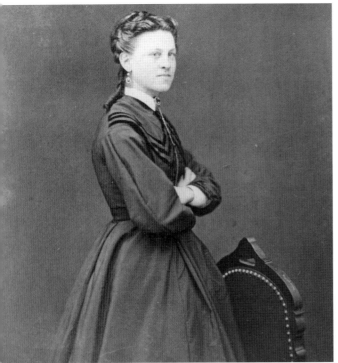

Ida Lewis

Lime Rock light keeper Idawalley Zorada Lewis was hailed "the bravest woman in America" during her lifetime (1842–1911). She had inherited the post from her father, filling the lamp with oil twice daily, trimming the wick, polishing reflectors, and extinguishing the light at dawn, as well as taking care of her three siblings and a sick mother, and other domestic duties. She was an excellent swimmer and deftly maneuvered her rowboat, seen here. She was only 16 when she made her first rescue and, later, earned the prestigious Gold Lifesaving Medal thanks to her heroic actions saving the lives of at least 18 people in Newport Harbor. The Life Saving Benevolent Association awarded her a silver medal plus $100, a fortune to a woman who earned $750 a year. (Courtesy of the Newport Historical Society.)

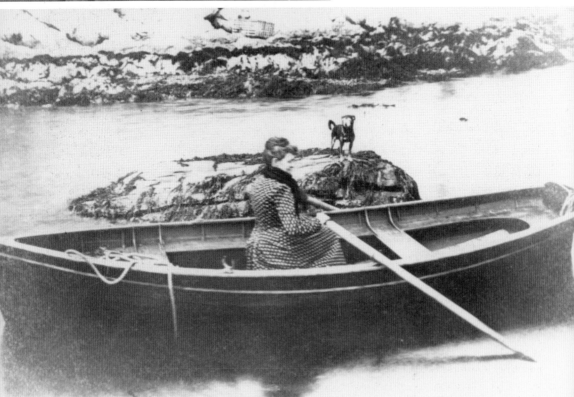

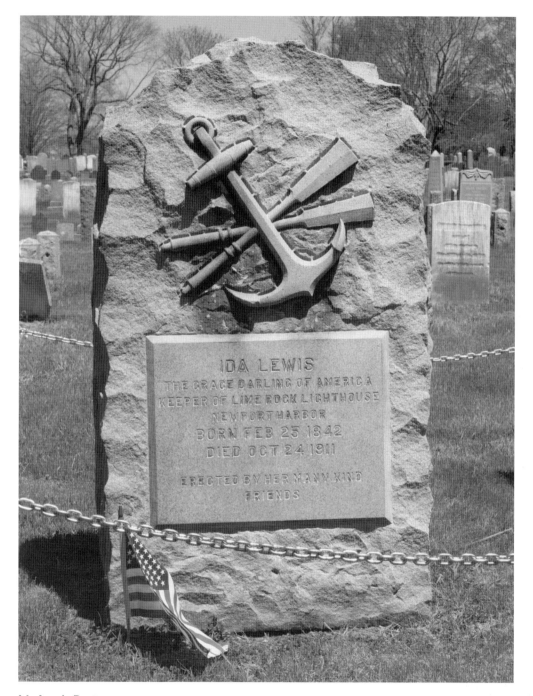

Ida Lewis Rests

After 39 years at Lime Rock Lighthouse, Lewis died in 1911, and is buried in the Common Burying Ground in Newport next to her father, Hosea. Her gravestone is substantially larger than his, which shows her popularity. It features two oars crossed by an anchor and is inscribed with "Ida Lewis / The Grace Darling of America." The gravesite is well maintained, with a chain surrounding it for protection, and is situated near a busy road for visibility to the public. (Photograph by Annie Sherman.)

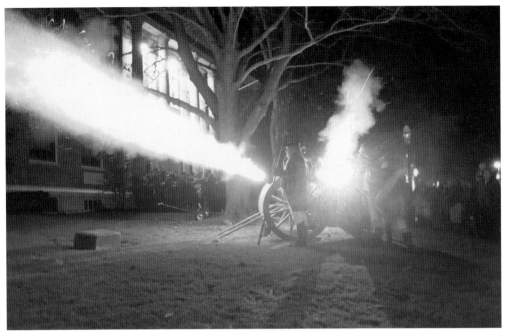

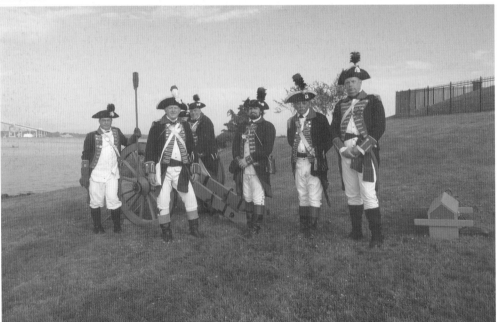

Newport Artillery Company
One of the oldest artillery companies in the country is still active in Newport, under the guidance of Col. Robert Edenbach. Established by a charter from King George II in 1741 to serve as "a nursery school for officers," the company is a ceremonial unit of the Rhode Island Militia, providing cannon salutes, color guards, and honor guards at official ceremonies, parades, and private events. Serving through the French and Indian War, American Revolution, War of 1812, Spanish-American War, and World War I, it also supplements existing units in times of peace. (Courtesy of Col. Robert Edenbach.)

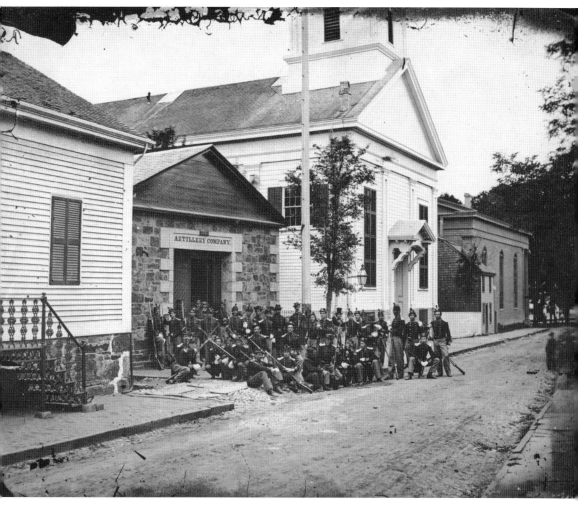

The Artillery Company Armory
The company is seen here around 1870 in front of the Clarke Street Armory, which now is a public museum featuring a collection of military uniforms and memorabilia. (Courtesy of the Newport Historical Society.)

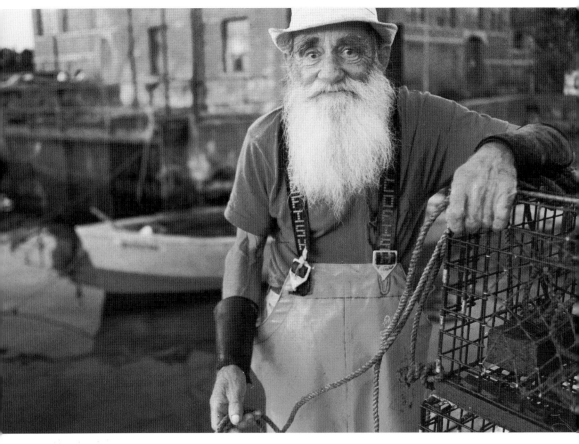

Louis Jagschitz
Known as "Louie the Lobsterman," Jagschitz (1921–2001) was synonymous with the local fishing industry, tending 140 lobster traps in Newport Harbor until he died at 80. After catching his first lobster when he was 12, he went on to own Louie's Bait Shop on Wellington Avenue, offering tricks, tips, and gear to customers. In his *Newport Daily News* obituary, his son August recalled childhood memories with his father: "When I was young, he used to take me on the boat and I used to try to drag the crab pots." State Pier No. 9 was named for him in 2002. (Courtesy of *The Newport Daily News*.)

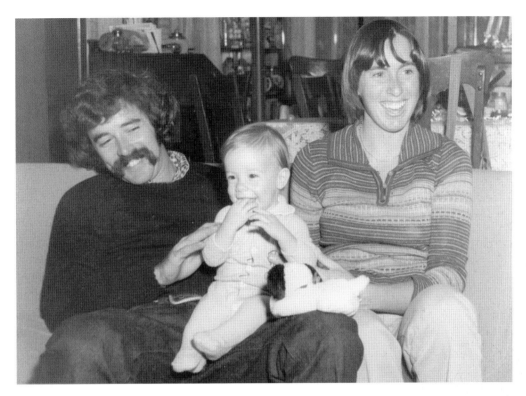

Kevin "Shorty" Dugan

An electrician with Newport Electric/National Grid for three decades, the man called Shorty (1951–2011) was the one to count on. A lifetime Fifth Ward resident and the first to respond to friends in need, Shorty said he was lucky to live here, especially when driving Ocean Drive every morning. When his wife, Barbara, a Newport School Department administrator for 30 years, was diagnosed with cancer, he took care of her for a decade, only to be diagnosed with the disease himself. "They didn't change the world by curing cancer, but they changed the world by touching the lives of those around them," Katie Dugan said of her parents. Barbara died in 2004 and Shorty in 2011. Katie now lives in the family home where both she and her mom were raised. (Courtesy of Katie Dugan.)

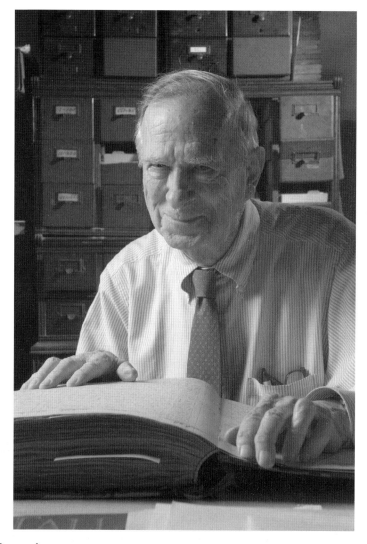

Leonard J. Panaggio

This unofficial city and state historian had a voracious appetite for reading and anything historic. His brain was an encyclopedic sponge, absorbing information from events and town happenings to people and places, while his basement office, seen here in 2009, still houses the result of his research including 1900s city directories, postcards, oceanliner menus, hundreds of boxes of his own slide photographs, and bound volumes of *The Newport Daily News* from a century ago. In case his memory failed, which it rarely did, he kept impeccable notes in a library-style card catalogue and scrapbooks of newspaper clippings, in no particular order. "He could answer any question," said his wife, Monique. "He knew everything about everything here." And Panaggio (1919–2012) did not just collect this information. He shared it. As the first state travel director, for 31 years, he was nearly a one-man publicity crusade for Rhode Island before tourism was Newport's cash cow. He beamed with pride during the 1976 Tall Ships Festival and the 1958–1983 America's Cup races, which he helped promote. In retirement, he continued to share his love of Newport and history in his twice-weekly "Grist Mill" column for *The Newport Daily News*, where newsroom staff remember him fondly, for always sporting a nice coat and tie and carrying his hat and overcoat when delivering his type-written column, with sweets for editors. (Photograph by Dave Hansen, courtesy of *Newport Life Magazine*.)

The Panaggio Family

Born in Newport to Italian parents, Leonard J. Panaggio served in the US Army Air Force in World War II and met Monique while stationed in Casablanca. They are pictured above after their wedding in 1944, before she arrived in Newport and he continued his four-year tour of duty. Their children, Len and Madeleine, also live on Aquidneck Island and remember they went to Old Sturbridge Village, seen below in 1949, and other historic places to encourage their interest in history. "He always took us to do things that interested him, and that were part of his job, hoping that we would be interested," remembered Monique, who was public relations director for The Preservation Society of Newport County. "He would have loved to see the exciting events happening in Newport now that he was involved in years ago." (Courtesy of Monique Panaggio.)

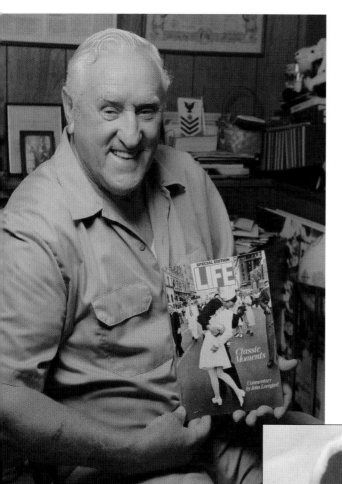

George Mendonsa

This Fifth Ward native grew up fishing with his father and brothers in Newport Harbor and then enlisted in the US Navy after the 1941 bombing of Pearl Harbor. On August 15, 1945, he was in Times Square courting his now wife when the news spread that Japan had surrendered. "Like any good sailor, I went into the bars and had a few drinks," he said in 2007. "Later, I was heading for the subway ... I saw this nurse ... and because of the excitement of the war ending, a few drinks, the nurse ... well, I kissed her." *LIFE* magazine photographer Alfred Eisenstaedt captured this iconic moment, and though the magazine never officially acknowledged him, Mendonsa (1923 to present) has photographic evidence to prove he is "The Kissing Sailor." (Left, photograph by Ron Cowie, courtesy of *Newport Life Magazine*; below, courtesy of George Mendonsa.)

Terry Moy

Terry Moy (1939 to present) enlisted in Newport in 1956, becoming a US Navy SEAL "frogman" by 1965, gathering intelligence and performing top-secret reconnaissance missions for amphibious landings as a member of the elite Underwater Demolition Team. After his second of five tours in Vietnam, he became an instructor at the training school in California, where he earned his nickname "Mother Moy" because of his ferocious attitude toward his students and training. The Newport native and resident says he is still competitive at 73 years old and exercises five times a week, competing with his four sons at the gym. In 1972, Moy had become chief and worked with NASA to command the Apollo 17 landing, the sixth lunar mission and the last one with a recovery at sea. Once the command module returned to Earth and had landed in the Pacific Ocean off the New Zealand coast, he was deployed from a waiting helicopter to attach an inflatable flotation collar to the capsule so it would not sink with the astronauts inside (seen here). The astronauts were transferred to the helicopter, and the module was lifted to a nearby aircraft carrier with Moy and his team. "Out of all the missions, it was flawless, the most successful," he said. "We couldn't have asked for a better day, there was not a ripple in the water. But the astronauts looked like hell, being up there for nearly two weeks."

Moy returned to Newport in 1975 and taught survival training at the US Navy's Officer Candidate School, where he was promoted to command master chief. "It's pretty cool being a high school dropout ending up a CMC in your home town," he said. (He spent four hours as a freshman at Rogers High School in Newport in 1953; he arrived the first day at 8:00 a.m., walked out at noon, and never went back.) He retired at the top of his game in 1979 after a 23-year career. But his military lifestyle was not easy to shake, so he went to work for the State Police Bomb Squad for 12 years. He later earned a degree in criminal justice at Roger Williams University; he said, "It only took me seven years to get a bachelor's degree." Now living a life of leisure in true retirement, he hunts, fishes, fixes up classic cars, and snowboards regularly out West. (Courtesy of Terry Moy.)

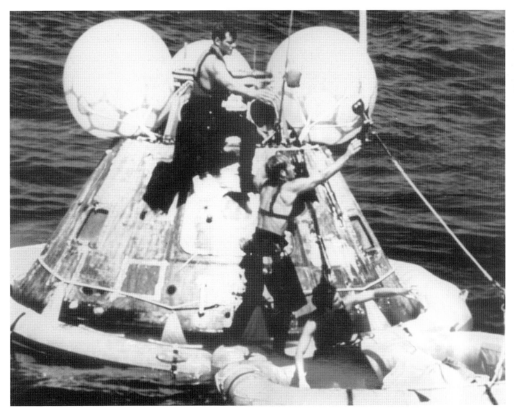

James Gillis

Jim Gillis spent more than three decades as an award-winning reporter and columnist for *The Newport Daily News*. He strived to be a journalist since high school in his native Pawtucket, so he pursued a journalism degree from the University of Rhode Island and arrived in Newport ready to cover the community's news. Professionally, Gillis (1958 to present) has never worked elsewhere, and he would not have it any other way. In his weekly "Spare Change" column that he started in 1986, he had an opportunity to provide amusing commentary of those characters and happenings about town. "I get to tell peoples' life stories. It's a pretty good gig," he said. "There are amazing characters here. The community never seems to run out of them." He is pictured here, at right, with longtime friend George Wein (see page 108). (Photograph by Dave Hansen, courtesy of *The Newport Daily News*.)

Timmy "The Woodhooker" Sullivan

Timmy "The Woodhooker" (1883–1957) was born in Fall River, Massachusetts, but grew up in Newport's Fifth Ward. This legendary vagabond held numerous jobs, from a grocery clerk to a laborer at the Naval Station, but he was best known for strolling local neighborhoods in his threadbare overalls with his wheelbarrow looking for spare wood and reusable items found in the garbage. The house he shared with his sister, "Dirty Julia," on the corner of Bellevue and Howe Avenues, became his storage facility, and neighbors filed formal complaints about the trash heap in his yard. The house was demolished shortly after Timmy's death. (Illustration by David Woods, courtesy of *Newport Life Magazine*.)

Richard Saul Wurman
The quick mind of this information architect has been compared to a hummingbird, yet Newport resident Wurman (1935 to present) is better known for asking questions than answering them. It is how he was raised: "We talked about things, and either we knew what we were talking about, or we were sent from the dinner table to look it up in the *Encyclopedia Britannica*," he said. After graduating from the University of Pennsylvania with bachelor's and master's degrees in architecture, he went on to found and direct the Technology, Entertainment and Design (TED) conference from 1984 to 2002, a gathering of luminaries from Jane Goodall to Bill Gates. He has written 83 books, including the *Access Travel Guides*, a series of guidebooks that map content by neighborhood, and received the 2012 Lifetime Achievement Award from the Smithsonian Cooper-Hewitt's National Design Museum. (Photograph by Danny Stolzman.)

CHAPTER THREE

Preservation and Development

Living history is a fundamental component of modern Newport. The wealth of existing homes and mansions, museums, historic churches, libraries, archives, and cemeteries showcases not only the value of good craftsmanship but also the need for preservation. Sometimes, though, not everything can be saved. To keep up with the demand for modern infrastructure and development, contemporary principles are welcome. Yet, without the careful forethought of the legends in this chapter, those who recognized value in defending the past to secure the future, that history might not have been saved.

The inimitable preservationist Doris Duke donated more than $400 million in today's dollars in her lifetime and founded the Newport Restoration Foundation (NRF) to preserve Newport's colonial homes. Her Rough Point estate, which she also preserved and bequeathed to NRF, is now open to the public, minus the two camels she kept as pets. Katherine Warren led the crusade to save Hunter House, a historic home in The Point neighborhood that exemplified Georgian colonial architecture in the 18th century. She later helped establish The Preservation Society of Newport County, which has since protected 11 significant historic properties. Not only buildings needed saving, but yachts as well. Elizabeth Meyer helped found the Museum of Yachting and the International Yacht Restoration School to showcase the history of the pastime and teach craftsmen to keep alive traditional and modern methods of boat construction.

Newport has seen its share of development, with two major projects permanently shaping the look of the city in the past 50 years. Francis "Gerry" Dwyer was chairman of the Rhode Island Turnpike and Bridge Authority and was largely responsible for the construction of the Newport Bridge in 1969, which allowed unfettered access to the west. Bill Leys led the Newport Redevelopment Agency for 33 years, directing the demolition and reconstruction of nearly a mile of prime waterfront property in the 1970s, from The Point to the Ann Street Pier. Clearly, the City by the Sea would not exist without the dedication and hard work of these big thinkers.

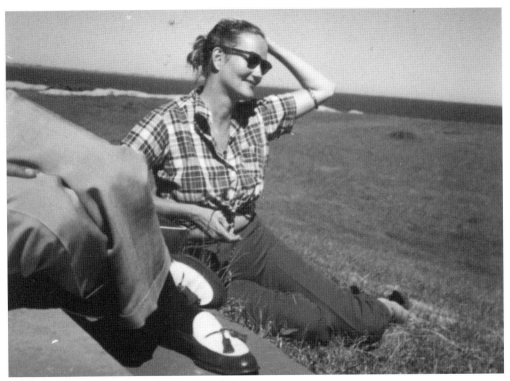

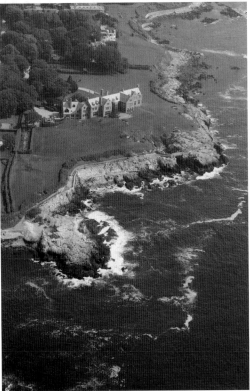

Doris Duke

The "richest little girl in the world," Doris Duke (1912–1993) was the only child of American Tobacco Company magnate James B. Duke, receiving her inheritance upon his death when she was only 12. She became an avid art collector, traveler, and advocate, enjoying her Newport estate, Rough Point, where she kept two pet camels. She was also passionate about historic preservation and financed the salvation of 83 historic buildings through the Newport Restoration Foundation, which she established in 1968. She even selected paint colors and made landscape decisions for the projects. Today, NRF continues Duke's vision, managing Rough Point and more than 80 colonial buildings, which are rented to tenant caretakers. (Courtesy of Doris Duke Photograph Collection, Doris Duke Charitable Foundation Historical Archives, David M. Rubenstein Rare Book & Manuscript Library, Duke University.)

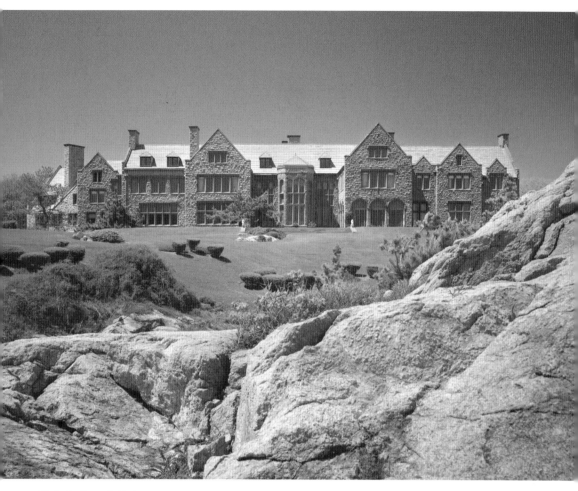

Duke's Rough Point
Doris Duke bequeathed her Rough Point mansion to the Newport Restoration Foundation, a nonprofit organization she founded here. It is open to the public for tours and events and is still decorated as it was when she lived there. (Courtesy of Doris Duke Photograph Collection, Doris Duke Charitable Foundation Historical Archives, David M. Rubenstein Rare Book & Manuscript Library, Duke University.)

Katherine Warren

This California girl (1897–1976) was an advocate of historic preservation, and with husband George and others, she led an initiative to purchase Hunter House (c. 1748, below) in 1945, learning of its potential ruin from stone carver John Howard Benson (see page 99). They helped form The Preservation Society of Newport County to restore it and other precious architectural gems. In 1962, they launched a public crusade to buy The Elms, enlisting the help of more than 30 donors, including local schoolchildren. The Warrens and other preservation society members decorated the house with period furnishings and art from their own collections so it could open to the public. Her involvement did not end with preservation, as she was also involved with the Newport Music Festival and the Newport Historical Society. (Courtesy of The Preservation Society of Newport County.)

Jack Grant

At the Seamen's Church Institute on Market Square, there is a pervasive desire to help mariners and members of the community. Such was the wish of the Wetmore sisters (see page 25) when they bequeathed a building and maintenance fund in 1930. Jack Grant (1945 to present) was the Seamen's Church Institute's superintendent for eight years, and now goes weekly to help community residents seeking support, assistance paying a bill, and advice in finding employment or resolving a personal issue. "This place oozes nonjudgmental compassion and understanding," said Grant, pictured here in the Institute's chapel. Below is a view of the building pre-1930, before the downtown waterfront area was redeveloped and the Seamen's Church Institute Building was constructed. (Right, photograph by Dave Hansen, courtesy of *Newport Life Magazine*; below, courtesy of Jack Grant and Seamen's Church Institute.)

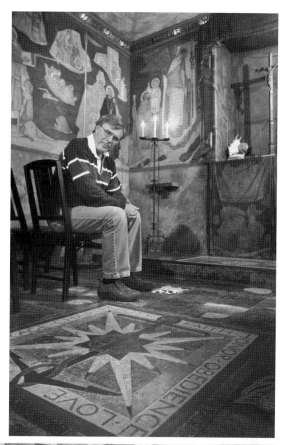

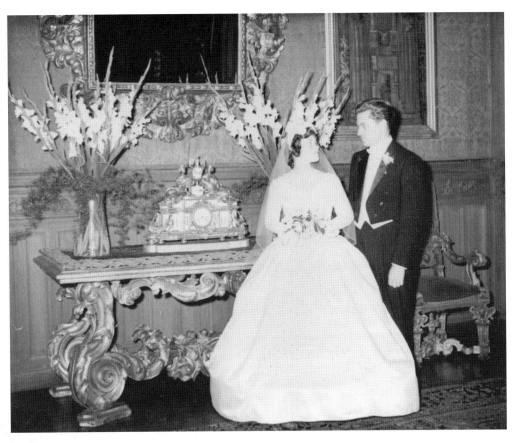

Harle and Donald Tinney

Little did 19-year-old Harle know that in May 1960, when she became a tour guide at Belcourt Castle (1894), she would marry its co-owner Donald. They eloped in December (seen here) and lived in the 60-room mansion with his parents, Ruth and Harold, and Ruth's aunt Nellie Fuller, a descendant of a Royal Exchequer and *Mayflower* passenger. His parents had bought architect Richard Morris Hunt's (see page 19) masterpiece, designed for Oliver Hazard Perry Belmont, to restore and preserve and to house their extensive antique collection. "When the Tinneys bought Belcourt in 1956, the term 'historic preservation' did not exist," said Harle (1941 to present). "They were way ahead of their time." With help from the Newport County Chamber of Commerce, they opened Belcourt to the public. It came alive when the Tinneys hosted galas for President Eisenhower and the Touro Synagogue Tercentenary. As many as 20 weddings and 80 galas every summer were held there, and dinners were magnificent recreations of 19th-century elegance. Since the museum was closed in the winter, the Tinneys, all craftsmen, bought a studio in Providence to make and restore stained glass. Later, to acquire licenses to cater weddings and events, the family bought Easton's Look bar in Middletown. They were elegant hosts for five decades. "It was incredible what those parties did for Newport," she remembered. "People filled hotels and restaurants, spent hundreds of thousands of dollars. We did it well."

When Harold died in 1989 and Ruth in 1995, Harle said the dynamic changed. Belcourt, a personal passion for the Tinneys, became a business with paid staff. "We managed to do okay but the best days were over," she recalled, in retrospect. Donald died in 2006, and with the building aged well past its centennial, Harle found it impossible to administer. In 2012, she sold the castle along with centuries of antiques. Retired, she moved to her own parents' house on Easton's Point in Middletown, with plans to write her own book on the history of Belcourt Castle. (Courtesy of Harle Tinney.)

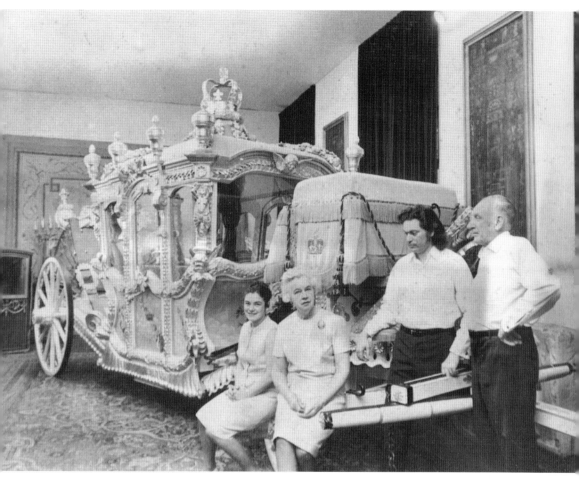

Belcourt Castle
Within two weeks of moving into Belcourt in 1960, Tinney had her first paranormal experience. She said she saw a full apparition of a monk walking along the hall. Since then, such events have been common, as additional residents, staff, and visitors have claimed to see strange things and witness ghosts, including the late Donald Tinney. The Syfy Channel television show *Ghost Hunters* has filmed at Belcourt. Seen here from left to right are Harle, Ruth, Donald, and Harold Tinney with their replica Louis XIV coronation coach they had constructed in 1960 for display. (Courtesy of Harle Tinney.)

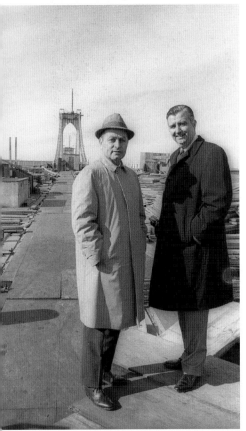

Francis "Gerry" Dwyer

Once Dwyer (1922–2011) returned to his hometown from the Korean War where he was a US Marine, he jumped right into local and state politics and was committed to his community for 60 years. Elected to two terms in the Rhode Island House of Representatives in the 1950s, he later managed John Chaffee's successful gubernatorial campaigns in 1962 and 1964, and was heavily involved in his bid for US Senate. Dwyer was also civic minded, involved with the Newport County Chamber of Commerce, where he served as its president, and was director of Bank of Newport for 33 years. He even worked with his father, James, in the family's Gustave J.S. White real estate, insurance, and auction business, until James retired in 1975, and Dwyer sold the business in the 1990s. It was Dwyer's familiarity with the legislature that served him well when he was appointed to the Rhode Island Turnpike and Bridge Authority (RITBA) in 1959, acting as chairman of the board for 12 years. In this public role, he was largely responsible for legislation that authorized construction of the Newport Bridge, a project that permanently changed the face of the city. Opening Newport's accessibility to the west, the bridge ultimately replaced ferry service from Jamestown. Voters defeated the first referendum, however, forcing Dwyer to launch a full-scale, statewide promotional campaign. It was later approved, and the bridge opened in June 1969, with Dwyer in the first car to cross it. "Newport's future is assured," he said during the opening ceremonies. He is seen at left, on the left, during bridge construction with James F. Canning, then executive director of the RITBA. (Courtesy of *The Newport Daily News*.)

William Leys (OPPOSITE PAGE)
A born and raised Newporter who never moved more than a few blocks from his childhood home, Bill Leys (1927 to present) graduated from Brown University in 1951 and then worked for a few years at his family business, Leys Century Store, which operated 201 years until it closed in 1997 (see page 74). He later spent several terms on the city council, but it was his 31 years as director of the Newport Redevelopment Agency for which he is known. With the agency, he helped transform the city's downtown area using a federal housing and urban development grant, buying property from West Marlborough Street to Market Square, demolishing rundown bars, businesses, warehouses, wharves, and factories. It sold other properties at a steep discount, including a decrepit Thames Street bar for $1 to a local businessman who moved it and turned it into one of the city's most popular restaurants. The agency then facilitated the rebuilding of nearly a mile of commercial harbor-front property, including Goat Island and the former "Fleet Landing" property on Washington Street. The installation of America's Cup Avenue is the best-known public construction project here, but the agency also was responsible for improvements in Perrotti Park, the Historic Hill neighborhood, and Queen Anne Square Park. A later project redeveloped West Broadway (now Marcus Wheatland Boulevard) and a portion of Broadway. Allowing access to Newport Harbor, the massive project helped the city embrace a new era of tourism in the 1970s that continues today. Leys remained the agency director until it disbanded in 1992 when the work was complete. Considered by some as the projects' mastermind, Leys published a memoir of the work in 2012 and continues to lecture about the projects' significance for the city. "A lot of people don't remember what Newport was like or what we went through during redevelopment," he said. "I was very lucky to be a part of it." (Photograph by Dave Hansen, courtesy of *The Newport Daily News*.)

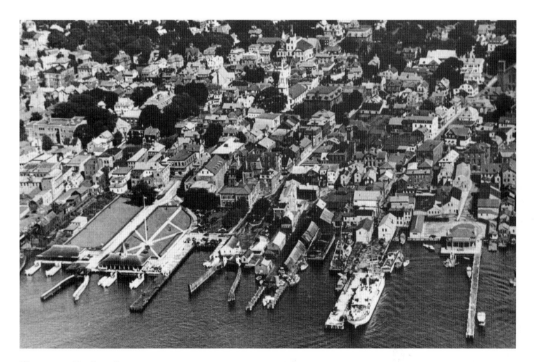

Newport Redevelopment
This aerial view of the waterfront in the late 1950s shows the massive scale of Newport's redevelopment in the 1970s and the impact of Leys's work. Government Landing, the large open area to the left, was redeveloped, and many buildings were removed between there and Trinity Church (the white steeple at center) and all along this expanse. America's Cup Avenue exists there now, which allows drivers to more easily flow through a busy area of town and also provides easier access to the waterfront. (Courtesy of the Newport Historical Society.)

Elizabeth Meyer

The youngest of four, Meyer (1953 to present) was raised in Baltimore, Maryland, by her parents who were accomplished sailors. She first went sailing when she was just six months old and has not stopped, buying and restoring her first boat, *Matinicus*, a 1960 Concordia 39, in college. The history of the sport and preserving its mainstays are equally important to her, so she turned that passion into a business by helping to establish the Museum of Yachting and the International Yacht Restoration School here. Responsible for saving and restoring *Shamrock V* (1930), *Endeavour* (1934), and more than 80 other yachts, Meyer received the President's Award from the National Trust for Historic Preservation. She now owns J Class Management and continues sailing and preserving classic yachts with her husband, Michael McCaffrey. She is pictured above as a child and at right at IYRS with *Coronet*. (Courtesy of Elizabeth Meyer; Photograph by Onne van der Wal.)

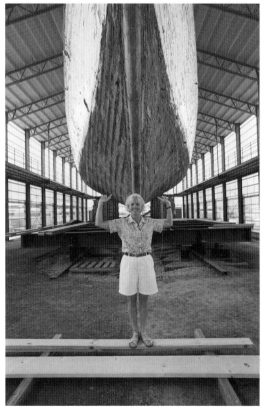

CHAPTER FOUR

Business and Politics

Though Newport is not known for its industrial or political prominence today, the conviction of its people through the centuries suggests more than just a capability for it, whether running a small business or lobbying at the state capital. Take Sen. Teresa Paiva Weed, for example. Born, raised, and still a Newporter, she is the first woman in Rhode Island to be president of the Senate and continues to campaign for her community. Guizio Brangazio, known as "Peanut Joe," immigrated here from Italy in the 19th century and sold peanuts from a cart in Washington Square. Athlete and advocate Paul Gaines fought segregation as a youth and rose to fame here as the city's and the state's first African American mayor in the 1980s. Then there's Judge Florence Murray, who battled sexism in the 1940s and 1950s to run her own law practice on Thames Street. She later became the first female justice of the State Superior and Supreme Courts. The Newport County Courthouse is named in her honor.

These people, and those featured in this chapter, have continued to fight since this city was founded. They fight for their beliefs, as well as for each other. Their resilience helps shepherd their city through multigenerational eras of business success. Small business and trade were the cornerstones of Newport dating back to the 17th century when it was a bustling port. Its business acumen rivaled New York until the Revolutionary War devastated it, but the Gilded Age ushered in a new period of prosperity when wealthy families played here. Now that tourism has enveloped Newport, it is primed to usher in a new era of legends based on the principles set by those in this chapter.

Guizio Brangazio

Italian immigrant Brangazio, nicknamed "Peanut Joe," sold peanuts from a wheeled cart in Washington Square from the late 1800s to early 1900s. He was known to feed the pigeons and to send money home to family. Several silver-plate photographs exist of him at work, which is rare for an immigrant peanut salesman when photography was in its nascent stages, but there is no record of him living, working, or dying here. (Courtesy of the Newport Historical Society.)

Herman Mines

Born in Russia, Herman Mines's shoe store was a fixture at 140 Thames Street for 67 years, and Herman (1891 or 1892–1989) was known to always be smoking a cigar. He also owned the building next door, including an alley, and while he shared the first floor with *The Newport Daily News* (see page 75), he allowed delivery boys to cart their papers from the presses to the trucks each afternoon. The storefront now is the Brick Alley Pub & Restaurant, and Mines's name is still on the front stoop. (Courtesy of the Brick Alley Pub & Restaurant.)

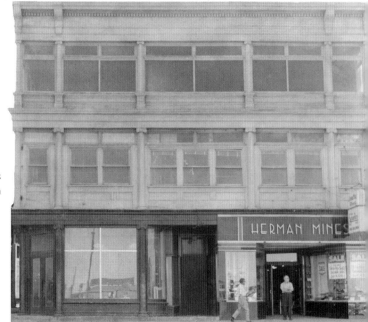

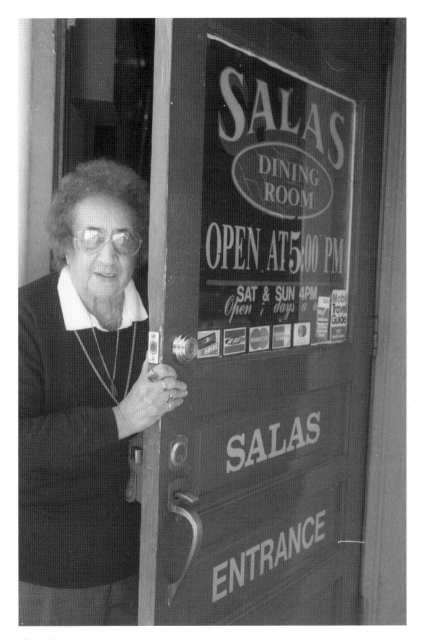

The Salas Family
The Salas family ran Salas Dining Room on Thames Street for 60 years. Francisco "Frank" came here with the US Navy during World War II and craved food from his native Guam, so he opened the restaurant in 1952 with wife Maria "Mary" and $150 borrowed from her father. They served jumbo portions at cheap prices, including a quarter-pound of oriental spaghetti, a specialty of Guam. Strong community supporters, the duo donated tons of food to nonprofits and fundraisers. Mary, a Newport native seen here in 1997, was even grand marshal of the 2002 St. Patrick's Day Parade, and had graduated from the Newport Police Department's civilian academy in her 70s. Frank died in 1998 and Mary in 2007, so their son Frank and wife, Sally, ran the restaurant, continuing the family's dedication to community causes. They sold the restaurant in 2012. (Courtesy of *The Newport Daily News*.)

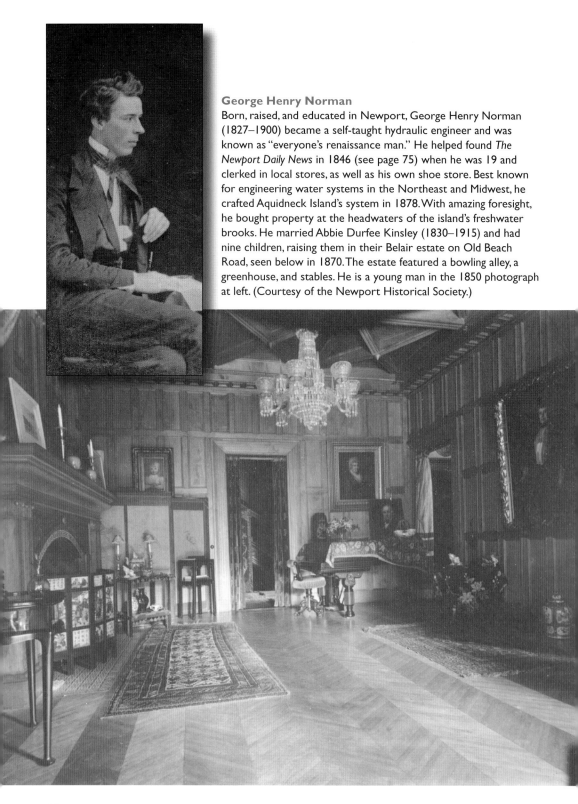

George Henry Norman

Born, raised, and educated in Newport, George Henry Norman (1827–1900) became a self-taught hydraulic engineer and was known as "everyone's renaissance man." He helped found *The Newport Daily News* in 1846 (see page 75) when he was 19 and clerked in local stores, as well as his own shoe store. Best known for engineering water systems in the Northeast and Midwest, he crafted Aquidneck Island's system in 1878. With amazing foresight, he bought property at the headwaters of the island's freshwater brooks. He married Abbie Durfee Kinsley (1830–1915) and had nine children, raising them in their Belair estate on Old Beach Road, seen below in 1870. The estate featured a bowling alley, a greenhouse, and stables. He is a young man in the 1850 photograph at left. (Courtesy of the Newport Historical Society.)

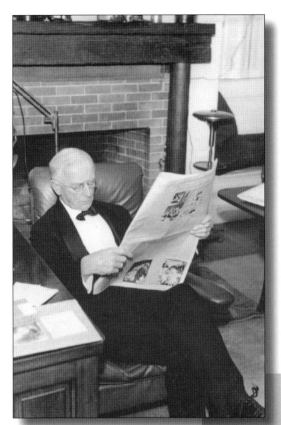

Bradford Norman and Mabel Norman Cerio
George and Abbie Norman's fifth child, Bradford Norman (1866–1950), managed the Jamestown and Newport Waterworks that his father established. His mind for finance led him to the Savings Bank of Newport, which he directed from 1932 to 1935, and the Newport National Bank from 1935 to 1942. With his father's nose for fresh water, he purchased land along West Main Road in Portsmouth across from modern-day Prescott Farm and built Brook Farm. He often had his nose buried in a newspaper, as seen at left at Brook Farm, Portsmouth, in 1940. His younger sister, Mabel Norman Cerio (1875–1949), was an accomplished artist. Before she married Italian George Cerio, she lived alone at the family's expansive farm in what is now Middletown. In her will, she stipulated that the entire property be conserved. The Norman Bird Sanctuary exists there today as a 325-acre nature preserve. (Left, courtesy of Daniel Jones; below, courtesy of the Norman Bird Sanctuary.)

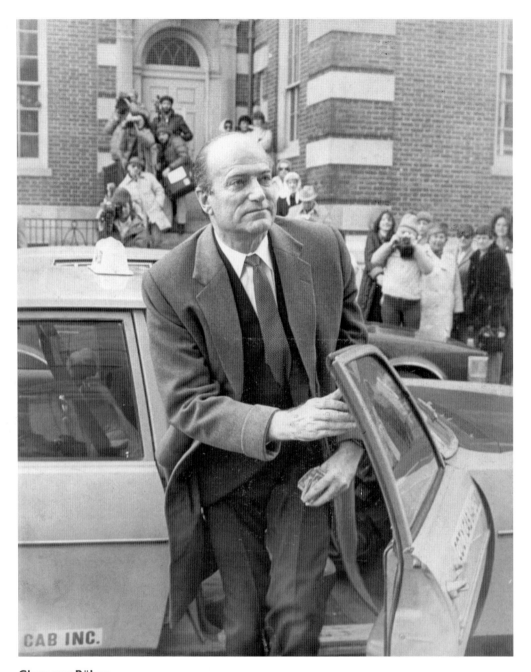

Claus von Bülow

This British socialite of European ancestry allegedly tried to poison his wife, Sunny, with an insulin overdose in 1980 at their Bellevue Avenue estate, Clarendon Court. Seen here appearing at the Newport Courthouse in 1982, von Bülow (1926 to present) was convicted and sentenced to 30 years in prison. He appealed and was found not guilty during two retrials. As a result, Sunny's family disinherited Cosima von Bülow, his daughter with Sunny, but he forfeited his bequest so she could inherit her mother's fortunes. The trauma left Sunny in a permanent vegetative state until her death in 2008. Von Bülow lives in London. (Courtesy of *The Newport Daily News*.)

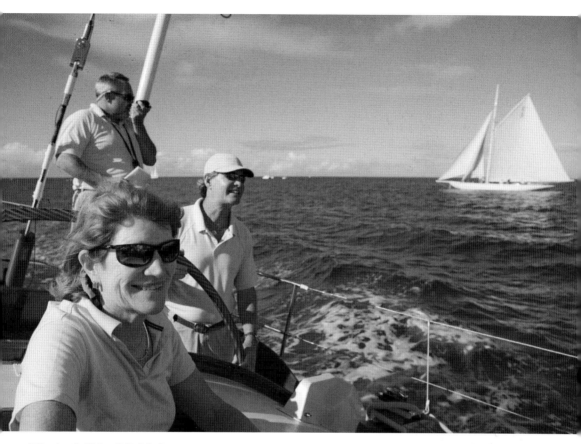

Elizabeth "Liza" Baldwin
Born and raised in Newport, Baldwin (1946 to present) was the mastermind behind a Ponzi scheme that robbed 49 Newport area investors of nearly $8 million. Charged with 91 felony counts of obtaining money under false pretenses, computer fraud, illegally appropriating funds, and embezzlement, Baldwin is serving eight years in the Adult Correctional Institutions in Cranston. "I'm very, very sorry for the pain and suffering I have caused," she said from the courtroom. She is seen here sailing aboard her yacht, *Van Ki Pass*, in Antigua in 2007. (Photograph by Cory Silken.)

Bobb Angel

Angel (1945 to present) has been the voice of Newport County for more than 45 years, programming radio shows and producing commercials on WADK AM 1540. He ended up there by chance. Bored by a string of odd jobs, he took a radio broadcast course, which led to an audition at the local station in 1967. He was 22. "I never expected to work at WADK … just didn't think it would be a good fit,'" he said from his production room. Angel has helped implement programming ideas there ever since, including announcing and broadcasting local school football and baseball games, for which he is best known. He was admitted into the Rhode Island Radio Hall of Fame in 2010. "In the early stages, it was just fun, then I learned there was community value to what I was doing." (Photograph by Jacqueline Marque, courtesy of *The Newport Daily News*.)

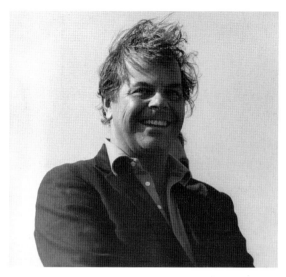

Dr. Mark P. Malkovich III

His Newport Music Festival attracted musicians from across the globe, performing in Newport's mansions during a three-week summer extravaganza. Malkovich (1930–2010), an accomplished pianist, actually inherited the festival when he was 45 after moving his wife and four children to Newport. He meant to manage it for a year, but four decades later, he was still involved in every aspect of the more than 60 concerts, attracting young talent as well as renowned performers. Malkovich also traveled the world, judging international music competitions and lecturing, all the while building an audience and spreading his love of music. He is seen below (second from left) with cultural attaché Eric Vorontsov (left), Russian pianist Andrei Gavrilov (center, with hat), and his four children, from left to right, Mark IV, Erik, Kent, and Kara in 1976. Mark IV now manages the festival, which celebrated 45 years in 2013. (Courtesy of Mark Malkovich IV.)

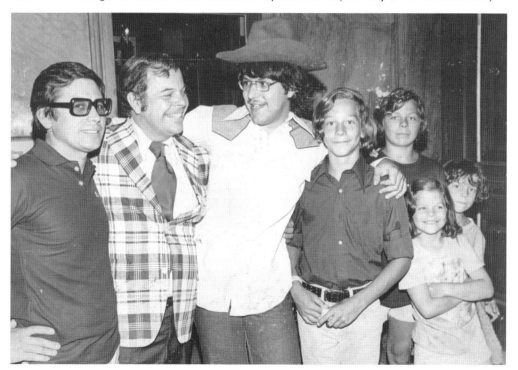

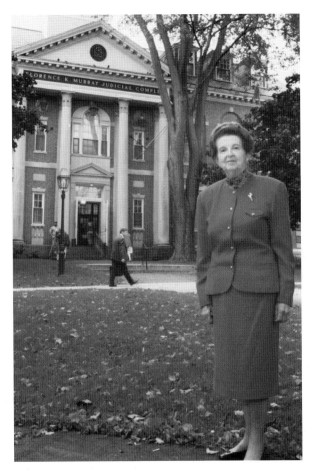

Judge Florence K. Murray
The first female State Superior Court and Supreme Court judge in Rhode Island, Murray (1916–2004) was born and raised in Newport's Fifth Ward and was teaching at the Prudence Island one-room schoolhouse when the Hurricane of 1938 hit. "My mother thought if I taught school all my life, that would be an accomplishment," Murray said in 2003. "My father said the future was greater for women than just being a teacher or secretary, but I had to be willing to put the time in." Apparently, that was all the encouragement she needed. After graduating from Boston University with a law degree (the only female to do so at the time) and passing the bar in 1942, she enlisted in the Women's Army Corps, attaining the rank of lieutenant colonel and earning the Legion of Merit Award in 1944. She married law school classmate Paul Murray in 1943, and said she had to get the Army's approval to wear her wedding dress because it was civilian clothing. Her lifelong dedication to education earned her a decade on the Newport School Committee starting in 1948, the same year she was elected to state senate, where she served four terms. That was also the same year her husband was elected to the Newport City Council. But this pioneer in education, law, and politics said it was her work as an attorney and judge that she most appreciated, blazing a trail through the "old boys' network" and encouraging other women to follow. "There were not many women then and you constantly had to prove yourself," she said in a 2003 *Newport Life Magazine* article. "My husband used to say, 'Florence, you knew when you were born it was a man's world. It's not going to change that fast.'" After she practiced law on her own on Thames Street (the first female to do so in Newport), she practiced with Paul and raised their son Paul Jr. while she continued to be a role model for women.

In 1990, the Newport County Courthouse in Washington Square was dedicated in her honor, a mere six years before she retired when she was almost 80. She is photographed here in front of that building in 2004. (Courtesy of *The Newport Daily News*.)

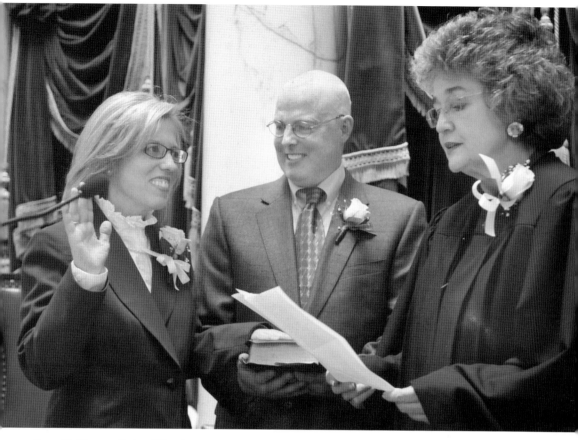

Sen. M. Teresa Paiva Weed

Her parents volunteered with Pop Warner Football, the St. Paul Society, and Knights of Columbus, instilling a sense of community involvement. So it is no surprise that Newport-born-and-bred Paiva Weed (District 13, Newport, Jamestown) has taken that obligation seriously, as the first woman to become president of the state senate, seen here with her late husband Mark during her 2008 swearing-in ceremony. As chairwoman of the Newport Affordable Housing Commission, board member of Fort Adams Trust, and supporter of myriad other local initiatives and organizations, Paiva Weed (1959 to present) said giving back to the community is vital. "I love our city very much," she said, between legislative sessions at the state house. "I've watched the many changes the city went through, and I'm honored to take the opportunity to ensure that the issues important in Newport are heard in Providence." (Courtesy of *The Newport Daily News*.)

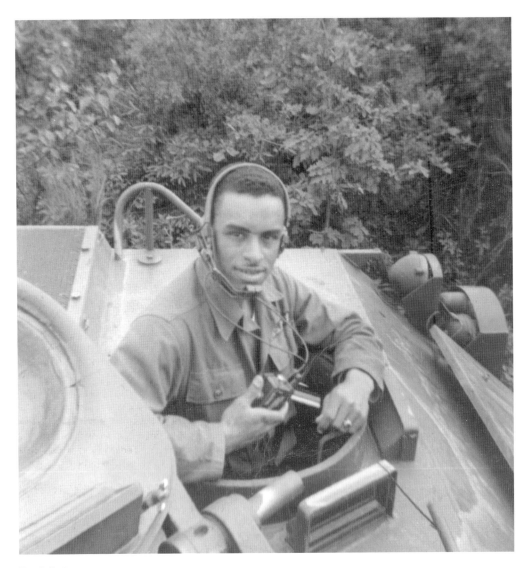

Paul Gaines

His sense of duty started early, when part of his Kerry Hill neighborhood was in jeopardy of being developed into a revitalized West Broadway in the 1950s. He joined neighbors, parents, and five siblings, along with cousin and mentor Eleanor Keys (see page 121), to speak out against the project, which was eventually relocated. That vocalism ignited in Gaines (1932 to present) a lifetime full of desire to give back to the community and country, including four years in the Army, two as a Morse code radio dispatcher (seen here in World War II). He taught and coached basketball in Newport Public Schools for nearly a decade, and later spent six years on the Newport City Council (1977 to 1983). But he is known for the two years he was the first black mayor in Rhode Island, despite the segregation he fought to get there. He is seen on the opposite page in his office in 1982. He still remembers sitting in the back of the bus and drinking from the "coloreds only" water fountain while attending Xavier University in New Orleans in 1951, which was four years before Rosa Parks refused to sacrifice her seat in nearby Alabama. Even with a college degree, he could not find work once he returned to Newport and worked briefly for a dry cleaner before another mentor helped him get a teaching job. "I'd still be pressing shirts if it weren't for the people who helped me," he said. (Courtesy of Paul Gaines.)

Paul and Jo Eva Gaines

Paul met South Carolina belle and homecoming queen, Jo Eva, in college, and the pair married in 1961. He said this storybook romance was a little unlikely; he was an athlete who disliked music, while she studied music and disliked sports. Now, with four grown children and two grandchildren, the duo fights for the community together and has won numerous awards. He led the battle to create Patriot's Park in Portsmouth, a memorial honoring the only black regiment to fight in the Revolutionary War. She is a vocal advocate for education, as longtime member of the Newport School Committee, leading the way for building the new Pell Elementary School, and as a member of the state board of education. They are seen here in 1996 when he retired from teaching at Bridgewater State University. (Courtesy of Paul Gaines.)

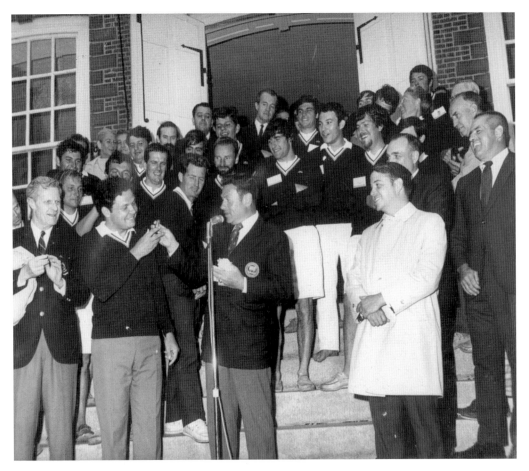

Dr. Frederick Alofsin

Born in Norwich, Connecticut, Alofsin (1918 to 1993) moved to Newport when he was just a few days old. Later trained as an orthodontist, he practiced for 36 years and, ultimately, became one of the city's biggest ambassadors. With no political background, he was mayor from 1967 to 1971 and ushered the city through the Newport Bridge construction in 1969. When the US Navy unexpectedly withdrew its active fleet in 1973, the city's economic and social structure was in transition. "He was among the first to realize tourism would guide Newport forward," said his son John Alofsin. "He was always thinking ahead." Alofsin (center, at microphone) recognized the untapped value of sailing to the city on the global stage and became a strong advocate for the sport. John remembers his dad entertaining members of the Australian and French America's Cup syndicates, serving as their official spectator boat for the races. To encourage a struggling French team, he presented them with a mini America's Cup (as seen here, with the son of pen magnate Bruno Bich, who sponsored the team, accepting the cup) and hosted grand parties to welcome them and foster international relations. Later, as first chairman of the Rhode Island State Yachting Committee, he lobbied at the state house to secure funding to attract events here. Newport's public sailing facility, Sail Newport, was one of the results of that effort, and the piers there are named in his honor. "His greatest legacy is that his relationships with people went beyond politics," John said. "He was networking before it was popular, and was extraordinarily good at it." (Courtesy of John Alofsin.)

Charlie Dana

Raised in New York, Newport Shipyard owner Charlie Dana (1947 to present) was 25 years old when he finally sailed from Martinique to Grenada. "I thought I had died and gone to heaven," he said. He arrived in Newport in 1977 and became part of three America's Cup campaigns: *Courageous*, *Freedom* in 1980, and *Liberty* in 1983. Now, the grandson of Charles A. Dana of Dana-Farber Cancer Institute is forging his own legacy. In 1987, he and 11 New York Yacht Club members bought and renovated Harbour Court mansion as its clubhouse. "We got a lot of support, and started to see a huge effect on Newport," he said. He was a Newport Restoration Foundation trustee during its renovation and public opening of Rough Point. Those projects were catalysts to saving Newport's last shipyard in 1998, and he said they were glad to help restore maritime jobs. The megayacht business is booming now, and his children are ensuring it remains an authority. (Left, photograph by Andrea Hansen, courtesy of Salve Regina University, Newport, RI; below, photograph by Billy Black.)

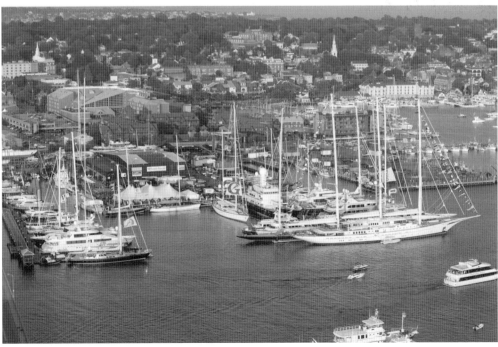

Phillip Shearman/Philip Sherman

Philip Sherman (1610–1670s) was 23 when he arrived from Yaxley, England, as an original settler in the 1630s. The name changed depending on who was writing it, but ultimately the man who farmed and sheared sheep was called Sherman. He signed the Portsmouth Compact in 1638, and became secretary under Gov. William Coddington in 1639. Since then, 12 generations of his descendants have lived here. Philip's great-great-grandson Job (1766–1848) established the family dry goods business in 1796 selling clothing and boots, groceries, and general produce, even camel hair underwear and bee furniture. A staunch Whig, he was an original trustee of the Savings Bank of Newport (now BankNewport). His five sons and a grandson followed him in business and as community leaders. Sons William (1801–1885) and David (1808–1865) continued as William Sherman & Co. Dry Goods. Job's third son Albert (1815–1884) and grandson Albert Keene (1844–1915) later became partners as well. Their building was on Thames Street, where the current Brick Market Place parking lot is. In the top photograph, standing in front of that building in the 1880s are, from left to right, Robinson Barker; William Anthony Sherman; his father, Albert Keene Sherman; and younger brother Edward Albert Sherman, the author's great-grandfather. By 1842, Job's fourth son, Edward (1809–1865), owned another store at 140 Thames Street in the building now occupied by the Brick Alley Pub & Restaurant (seen in the mid-1800s in the bottom photograph). They lived upstairs until Edward died, and his son Walter managed the business. He sold it in 1885 but kept the building. Albert Keene sold his side of the dry goods businesses in 1912 to William Leys (see page 57), who operated the modern Leys Century Store with son David. Shermans remained involved in the business until it closed in 1997, and it was one of the oldest in the country to have continuous family involvement. (Courtesy of Albert "Buck" Sherman Jr.)

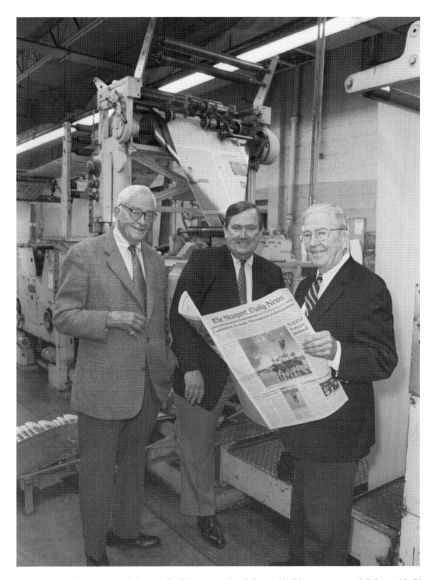

Edward A. Sherman, Edward A. Sherman Jr., Albert K. Sherman, and Albert K. Sherman Jr.
The Shermans remained active in the business world. Albert Keene's son Edward Albert (1879–1934) was a banker at Newport Trust Company before he bought *The Newport Daily News* in 1918, with offices on Thames at Church Streets (opposite Queen Anne Square). In 1930, he relocated to his great-uncle Walter's dry goods building at 140 Thames Street. They moved the presses on a Saturday and never missed a deadline. Many additional businesses were tenants there in the early 1900s, including Herman Mines's shoe store (see page 60), which shared the first floor. Edward's sons Edward "Ned" Sherman Jr. (1915–2006), the author's great-uncle, and the author's grandfather Albert "Al" Keene (1918–2006), took over the business in 1948 when they returned from World War II. Ned, co-publisher and editor, and Al, co-publisher and general manager, remembered posting breaking news, including the Kennedy assassination, in the windows for passersby. In 1970, Al and his son, Albert "Buck" Keene Jr. (1943 to present), the author's father, built a new production facility and sold the building that was in the family for 127 years. Here, from left to right, Ned, Buck, and Al are at the press in 1998. (Photograph by Kathryn Whitney Lucey.)

Sen. Claiborne deBorda Pell

Pell (1918–2009) was the state's longest serving US senator, advocating for education, the arts, international relations, and arms control for 36 years. His father, a US minister to Portugal and Hungary, moved the family to Newport when Pell was nine, where he attended St. George's School. After receiving degrees at Princeton and Columbia, he traveled to Europe, going through Poland, Hungary, and Czechoslovakia. He was briefly detained by Nazi Gestapo in Poland and interrogated six times by Fascist and Communist police in his career. Four months before Pearl Harbor, he enlisted in the US Coast Guard and began as a ship's cook.

His war experience and travels instituted an aversion to war as a solution to international disputes, so in 1945, he participated in the San Francisco Conference, helping to draft the charter of the United Nations. He still carried a copy of the charter in his pocket 50 years later. After the war, he went into the US Foreign Service, assigned to posts in Italy and Czechoslovakia until 1952. When Pell entered politics in 1960, he was a political unknown. "I knew I wanted to be in public service," he said in a 1999 *Newport Life Magazine* article, "and I can't think of a job where you have greater opportunity to influence the course of events than that of a US Senator." He sponsored legislation that established the National Endowments for the Arts and the Humanities, two agencies that still award grants to artists and intellectuals; supported the National Sea Grant College Program; pushed for an international treaty to ban nuclear weapons testing on the ocean floor; and wrote legislation that established the Basic Educational Opportunity Grants, later renamed the Pell Grants, which enabled lower-income families to send their children to college. One in five Americans now have gone to college with a Pell Grant as part of their financial aid.

Known for his civility, truthfulness, unending reserve, and spending time with his four children and grandchildren and wife, Nuala, Pell retired in 1996 after receiving 40 honorary degrees and inspiring international, national, and statewide affection. The bridge to the city is named in his honor. He is seen here lecturing at Salve Regina University, where the Pell Center for International Relations and Public Policy also is named for him. (Courtesy of Salve Regina University, Newport, RI.)

CHAPTER FIVE

Sports

Newporters have a hard time sitting still. It is no wonder, then, that athletes find a home here, whether they were raised on Newport's baseball diamonds, surfed its shore- and reef-breaking waves, or were attracted to Narragansett Bay for its consistent southwesterly breezes. Though national teams do not have home field advantage in Newport, sports and sporting events have been popular here since the 1800s when car racing, equestrian activities, and polo were trendy. (Polo matches between teams from around the world are played at the Glen recreational fields in nearby Portsmouth.)

Sailing is Newport's primary recreational and professional activity. The city hosted races for the sport's oldest trophy, the America's Cup, for 53 years starting in 1930. When the longest winning streak in sporting history ended in 1983, and the races went abroad, the city rebounded with Sail Newport, a public sailing facility now led by director Brad Read, that hosts more sailing events here than ever before. Given Newport's prime location surrounded on three sides by water, other water sports continue to thrive here, including surfing. One local surf master, Sid Abruzzi, led the successful battle against the city's ban on the sport in 1971, and since then has surfed on, and fought for, these waves every day.

Other sports and their athletes have seen increasing attention. The Newport Gulls have been the No. 1 team in the New England Collegiate Baseball League five times since 2001. They play in one of the country's oldest baseball fields, Cardines Field, dating to 1908. It was built on "The Basin," a swampy bog once used as a water source for steam locomotives at the nearby train station. Hosting the International Tennis Hall of Fame & Museum also allows Newport to boast some authority in racquet sports. Established in 1954 by legend Jimmy Van Alen, the facility now hosts the only grass-court competition in the country in a National Historic Landmark building. The champions, paralympians, yachting preservationists, and philanthropists on these pages are all sporting legends.

James H. Van Alen

Jimmy Van Alen (1902–1991) was a singles and doubles tennis champion and an ardent supporter of the game. He helped establish the National Tennis Hall of Fame at the Newport Casino in 1954, lobbying the US Lawn Tennis Association (now the US Tennis Association) to sanction it, and saved the historic property from development into a parking lot. It is now the International Tennis Hall of Fame, which is home to the largest tennis museum in the world and hosts the only professional lawn tennis tournament in the country each July (see page 20). Van Alen also paved the way for easier scoring by inventing the Van Alen Simplified Scoring System, now called the Tie Break, which revolutionized the game by ending long sets. He is seen here in 1961 escorting guests into the museum. (Courtesy of the International Tennis Hall of Fame & Museum.)

Van Alen's Dedication
Sublimely dedicated to his Hall of Fame, Van Alen was proud to show it off during the summer season. He is seen here (second from right), with, from left to right, Rhode Island governor Dennis Roberts, Count Rochambeau, Rhode Island senator Theodore F. Green, and Tennis Hall of Fame president William Clothier at the July 9, 1955, National Lawn Tennis Hall of Fame dedication ceremonies. (Courtesy of the International Tennis Hall of Fame & Museum.)

Jimmy and Candy Van Alen
Van Alen also was a community-minded man who followed respected traditions. Every holiday season with his wife Candy, seen here, he would read 'Twas the Night Before Christmas to children on the grounds of his hallowed Tennis Hall of Fame. (Courtesy of the International Tennis Hall of Fame & Museum.)

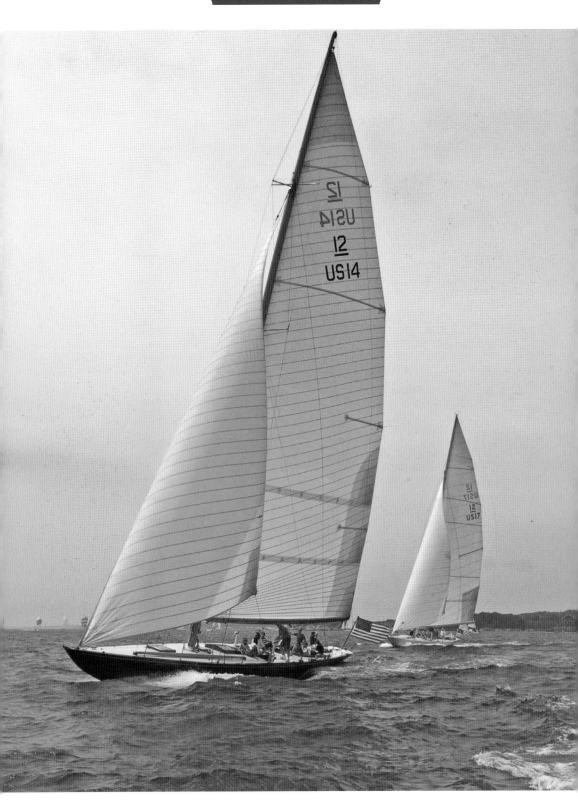

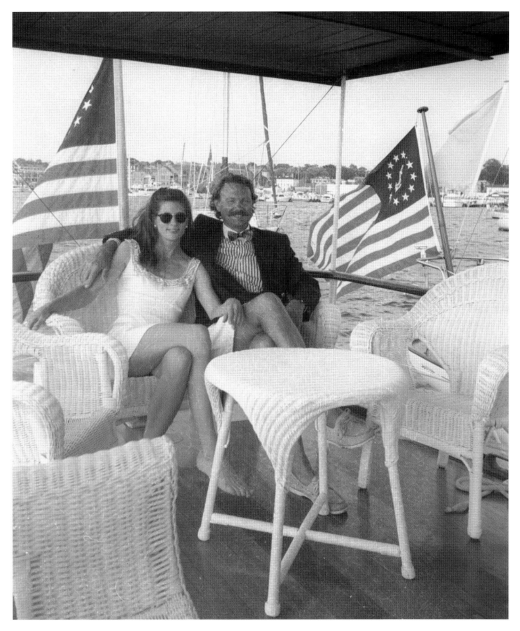

Bob and Elizabeth Tiedemann
Restoring classic wooden yachts is the Tiedemanns' lasting impact on Newport's waterfront. In 1975, Bob bought his first 12 Meter, *Gleam* (1937), and then rescued from the bottom of a Michigan lake *Northern Light* (1938), seen at left cruising in Newport. "He saw abandoned old boats being cut apart and couldn't let it happen anymore," said Elizabeth from their Hilltop home, which she said was like restoring a wooden boat except it leaked from the top, not the bottom. Under Seascope Yacht Charters they restored additional boats together, returning them to the cruising and America's Cup–style racing for which they are internationally renowned. Bob also helped establish the Museum of Yachting. Though he died in 2006, Elizabeth continues Seascope and his legacy. Pictured above is their wedding day aboard M/V *Pam*, July 10, 1994. (Opposite, photograph by Lane DuPont; above, courtesy of Elizabeth Tiedemann.)

Brad Read and Ken Read

Brothers Brad (1964 to present, left) and Ken (1961 to present, opposite page) have been sailing since before they could walk and have made the sport their life's work. Growing up in Seekonk, Massachusetts, they regularly cruised with their mom and dad, a seasoned sailor and Newport-to-Bermuda race winner. Those weekend trips molded them as sailors, people, and adventurers, said Ken. But "Newport's sailing scene then was all about the America's Cup," said Brad. "Watching the 12 meters being towed out of the harbor was a daily ritual. Teams also would train inside the bay, which was magical for us as we could be near our sailing heroes." The sports fanatics were also devoted hockey players and named their Sunfish and dinghy "Bobby Hull" and "Bobby Oar" after the famed players. They later became the only brothers ever to win the College Sailor of the Year Award. Their impressive professional careers have garnered them international acclaim, both on the water and off. Brad is a three-time J/24 world champion, two-time 12 Meter champion, plus multiple other national and world titles. He now is executive director of Newport's public sailing facility, Sail Newport, which has "brought scores of international sailing competitions back to Newport Harbor since 1983," said

Brad. Ken is a six-time J/24 world champ, two-time Rolex Yachtsman of the Year, helmed three America's Cup campaigns, and completed two Volvo Ocean Races as PUMA Ocean Racing Team's skipper and CEO. He is now president of North Sails Group, the world's leading sail maker. "Brad and I were born with the ability to make a boat go fast," said Ken. "And I can tell you we both hate to lose!"

Aside from the success and accolades, the brothers remain dedicated to promoting Newport as a top global maritime destination and to educating youth about the benefits of sailing. During the past eight years, Brad has helped Sail Newport increase its youth sailing program by 400 percent, and Ken lectures to students and youth sailors, giving tours of the VOR boats. "The rewards of learning to sail are the life lessons taught," said Brad. The lessons include "self reliance, situational awareness, self esteem, and a healthy respect for the environment." Opposite, Brad celebrates the America's Cup World Series in Newport with skipper and Oracle Team USA CEO Russell Coutts. Above, Ken drives PUMA Ocean Racing Team's *Mar Mostro*. (Opposite, photograph by Jacqueline Marque, courtesy of *The Newport Daily News*; above, photograph by Amory Ross, courtesy of PUMA Ocean Racing Team.)

Dr. Robin Wallace

After 35 years practicing medicine and watching his father as physician for the 1964 British America's Cup team, Wallace (1936 to present) began a crusade. An avid sailor, he felt the void in Newport after *Liberty* lost the Cup in 1983 (below). To fill it, and to help Newport remain a sailing destination, he helped create Sail Newport, the city's only public sailing center. He served as its first president, and the youth sailing center bears his name. "We began in small ways, but it's been a tremendous asset to this community and for sailing. I'm very proud of that legacy," he said. He is still active on the Rhode Island State Yachting Committee and serves on national and international race committees, including one of the largest weekly keelboat series in the country, the Shields fleet race, seen above in 2010. (Above, photograph by Dave Hansen, courtesy of *Newport Life Magazine*; below, courtesy of Robin Wallace.)

Paul Callahan
The 2012 New York Yacht Club Yachtsman of the Year competed in the Paralympics in London 2012 and Sydney 2000. His efforts getting there have inspired youth sailors closer to home, especially at Sail to Prevail, a nonprofit that Callahan has directed for 16 years. The organization creates opportunities for children and adults with disabilities to overcome adversity through therapeutic sailing. Callahan used this method to surpass his own injury—he slipped on a wet floor while a Harvard University student and broke his neck. Fifteen years after becoming a quadriplegic, Callahan learned to sail at Sail to Prevail (then Shake-A-Leg). "Being disabled, I've been given a gift," Callahan said. "I look at it as a way to push through adversity for confidence building, to overcome challenges in daily life." (Photographs by Mick Anderson and Alex Egan, courtesy of Paul Callahan.)

The Newport Gulls

The No. 1 college baseball team in New England in 2012 plays at Cardines Field, a wooden ballpark built in 1908 that is arguably the oldest in the country. The Newport Gulls are college players here for a two-month season, living with local families, reading to school children, and participating in fundraisers, like an event where the entire franchise shaved their heads to raise $17,000 for charity. General manager and owner Chuck Paiva said it is not just about winning championships. "As important as it is to be the best player, you have to be a good kid too," he said. "We have what some consider the best college baseball franchise in the country. We are very humbled." Paiva has managed operations since 2001 when the franchise was relocated from Cranston; Paiva recruits players with fellow vice president of operations and owner Chris Patsos, plus partners Mark Horan, Ron Westmoreland, and Greg Fater. (Photograph by Melissa Paiva, courtesy of Newport Gulls.)

The Championship Team

In August 2012, the Newport Gulls won their record fifth New England Collegiate Baseball League (NECBL) championship since 2001, breaking several offensive NECBL records, including home runs and on-base percentage. Rallying with the Fay Vincent trophy, below, the team later celebrated at a cookout hosted by general manager Chuck Paiva. "This team is pretty good, and every one of these guys, at some point, carried the team," said Paiva in a *Newport Daily News* article. "They're all special players." At right, the team mascot, Gully, is a huge crowd favorite. (Photographs by Melissa Paiva, courtesy of Newport Gulls.)

Sid Abruzzi
Abruzzi (1951 to present) had just turned 20 when he was arrested in 1971 for breaking the city's decade-long surfing ban along Cliff Walk. Three months later, a Rhode Island Superior Court judge overturned the ruling, and the ban was lifted, opening the best stretch of waves in town and vaulting the Fifth Ward native into local record books. He has surfed every day since then, opening Water Brothers surf shop in 1971 to fuel his passion. But the son of Newport's famous baseball coach and physical education director Duke Abruzzi is not just a surf bum. He will be inducted into the East Coast Surfing Hall of Fame in 2014 and hosts fundraising events for his Water Brothers Foundation. He is seen here in 1998 at Sachuest Beach in Middletown. (Photograph by Kathryn Whitney Lucey.)

CHAPTER SIX

The Arts

As the sun glistens off Narragansett Bay or emits a blood-orange glow while setting behind Newport Bridge, photographer Sandy Nesbitt captures it in a photograph while his brother Rupert paints it on canvas. As a wave breaks at Easton's Beach and echoes across the island, sculptor Kay Worden molds the watery arc in bronze and displays it downtown for all to see. As a maple leaf floats to the ground from its lofty perch in the autumn, silversmith Alfredo Sciarrotta casts its shape into a shining bowl. As the sounds of Dizzie Gillespie's trumpet or Natalie Cole's smooth voice waft across the Newport Jazz Festival crowd at historic Fort Adams State Park, longtime festival organizer George Wein closes his eyes and dreams of the next show.

With plenty of scenic vistas to inspire in Newport, its innovative, artistic minds have much to capture, and capture they do in photographs, paintings, sculptures, books, pieces of jewelry or silver dishes, music albums, antique furniture or clocks, and even tombstones. For nearly four centuries, Newporters have created what inspires them and what makes them happy, as well as what they need. Yet that happiness comes from more than just a pretty view. It comes from making others happy too, teaching them to create something from nothing. Art is not always a physical thing, however, as education is an art here, too. Opportunities to learn abound from lectures and classes at historic organizations, museums, libraries, even monthly art gallery nights, to the works of individual experts like those artists on the next few pages. Since sharing their art is as important as making it, these local creators have been included here to further share their work and recognize their contributions to this community. Though not all of Newport's talent could be included here, their work as a collective is an inspiration.

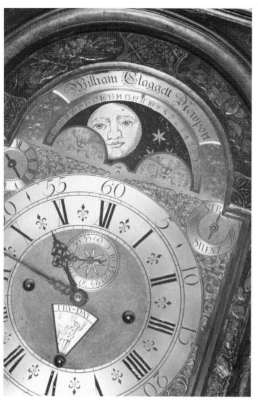

William Claggett

One of the best clockmakers of his time, Claggett (1696–1749) was also a compass maker, organ builder, engraver and printer, author, notary public, and experimenter in electricity. He inspired other clockmakers to turn beautiful works of art into functional timepieces and regularly worked with craftsmen Townsend and Goddard (see opposite page) to create the framework for his famous mechanisms. While most clocks then had only the hour hand, Claggett added the minute hand for more accuracy. He taught the trade to his sons and grandson Thomas, William II, and William III, who continued the business. He also was known to sign his creations, like these clocks considered two of the oldest American-made clocks in the country. The clock shown at left is from around 1728 and is located at the Redwood Library and Athenaeum; the one below is from around 1732 and is at the Newport Historical Society. (Photographs by Dave Hansen, courtesy of *Newport Life Magazine*.)

Job and Christopher Townsend, and Daniel Goddard

These two Quaker families were the best furniture makers of their time. Job Townsend (1699 or 1700–1765) and his brother Christopher (1701–1773) teamed with Daniel Goddard (1697–1764) to establish the business, later teaching their sons John Townsend (1732–1809) and John Goddard (1723 or 1724–1785), who perhaps were better known. More than a dozen family members learned the trade through a century of living and working on an entire square block in the city's historic Point section. A few of their homes still exist there, though others were demolished during the city's redevelopment project of the 1970s. Known for the exquisite hand-carved scallop shell details, the desks, highboy bureaus, and cabinets sometimes featured elegant ball and claw feet, all carved in heavy West Indies mahogany to withstand centuries of use. Many pieces still are in the Newport area today, including this 18th-century secretary-style desk, and others are in museums and galleries across the country. Their furniture has sold at auction in recent years for upwards of $10 million. "John Goddard and his work, no matter who trained him or in what tradition he was trained, no one can study (them) without the feeling that they are the work of one who leads, not follows, who is a master and not disciple," wrote architect Norman Isham. (Photographs by Annie Sherman.)

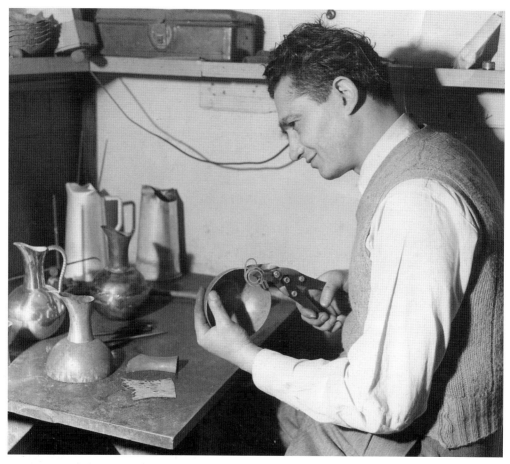

Alfredo Sciarrotta

An Italian engineer and naval officer, Sciarrotta (1907–1985) was working in a munitions factory in German-occupied Italy in 1943 under the scientist and professor who invented the first magnetic torpedo. When Italy fell to the Allies, Sciarrotta's undersea weaponry expertise was an incredible asset to the United States, so he was smuggled here by the Office of Strategic Services, precursor to the CIA. He and a team of scientists and engineers packed trunks with torpedo-related hardware and tools, plus two small submarines and a torpedo that Sciarrotta knew had been sunk by the Germans in the Port of Naples to protect the secret hardware from the Allied war effort. The team left for North Africa, where they boarded a convoy for the transatlantic voyage to Virginia. Once in Newport, the scientists and engineers built exploding magnetic torpedo devices and two-man submarines at the Naval Torpedo Station on Goat Island. Sciarrotta's code name for this top-secret mission was "Mr. West." He married his English teacher, Newporter Margherita Russo, in 1944. Though he and his team were offered government jobs after the war, the Sciarrottas settled in Newport and raised three daughters in their Kay Boulevard home. He opened a silversmith shop on Liberty Street and applied the same precision and skill to his patented leaf designs as to his weapons. His daughter Rita, who lives in Connecticut and New York, said he rarely discussed his involvement with the war and his silversmithing with the family, but "finding his work in antique shops in New York in the 1990s made me want to know more about what he did." She now collects antiques to study his remaining pieces. By the time he retired in 1975, several of his designs were in the Smithsonian Institution. The Newport Art Museum, whose school is now where Sciarrotta's original workshop was and where he is pictured here, also has a large Sciarrotta bowl on display. (Courtesy of Rita Sciarrotta.)

Sciarrotta's Silver
Alfredo Sciarrotta's silver serving dishes, bowls, cigarette cases, vases, and trophies were sleek, stylish, and simple, with little ornamentation other than a signature stamp (seen at top). He designed gifts for Presidents Eisenhower and Kennedy, Italian premiers, and boxer Rocky Marciano. Though he shied from the limelight, his work garnered him national recognition, including commissions from Cartier and Shreve, Crump & Low, the Kentucky Derby trophy, and jewelers and department stores across the country. (Photographs by Annie Sherman.)

Edith Jones Wharton

The phrase "Keeping up with the Joneses" allegedly referred to her father George Jones's family. Wharton (1862–1937) was better known for her writing, publishing her first book of poems at 16. She wrote more than 40 novels, short stories, and poems from her residences in Newport (Pen Craig), New York, and France, including *The Age of Innocence*, for which she was the first woman to win the Pulitzer Prize for Fiction. After marrying Edward Wharton, she lived in Land's End, a mansion off Bellevue Avenue. Taken on the lawn at Pen Craig around 1884, the photograph below shows Edith standing at right next to her cousin Miss Edgar. Seated from left to right are Mr. Hoyt Gould; Edith's mother, Lucretia Jones; and Edward Wharton, whom she married a year later. The other shows her at work. (Courtesy of the Yale Collection of American Literature, Beinecke Rare Book and Manuscript Library, reprinted with permission of Edith Wharton estate and Watkins/Loomis Agency.)

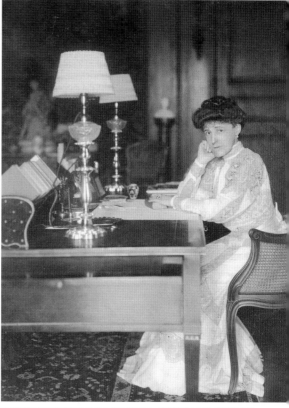

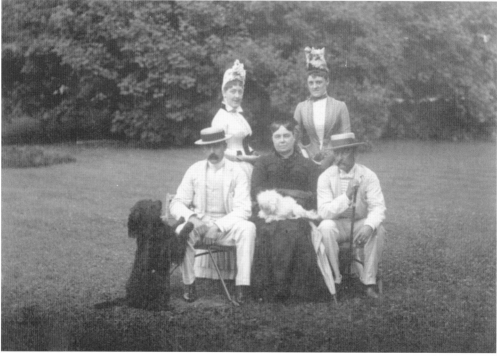

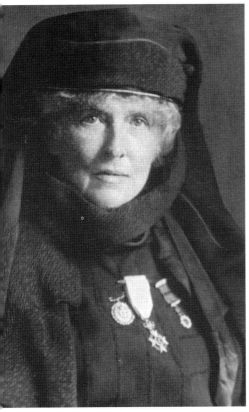

Maud Howe Elliott
Elliott (1854–1948) dedicated her life to the arts, advocacy, political activism, and writing. Raised in Portsmouth, she married artist John Elliott in 1887 and spent much time in Rome, returning to Newport in 1910 to settle the affairs of her late mother, Julia Ward Howe, author of "Battle Hymn of the Republic." Believing in the resurgence of American artists, she was a mastermind behind the Art Association of Newport, now the Newport Art Museum (NAM), established in 1912, and assembled regular exhibitions of prominent local artwork. "She was the first to lecture and publish on the unique position that Newport held in the lives of colonial artists," wrote NAM curator Nancy Whipple Grinnell. In 1916, she and her sister Laura E. Richards shared the Pulitzer Prize for a biography of their mother. (Both photographs by Bachrach, courtesy of the Newport Art Museum Archives.)

Muriel Barclay de Tolly

She owned a French nursery school and a couple of restaurants, made it into the Chowder Hall of Fame, raised six children, and lived in cities across the country. Muriel Barclay de Tolly (1930 to present) also has written and illustrated best-selling children's books based on Puma, the family cat, and now paints simple watercolors that line the walls of homes across Newport County, including her own. This Montreal native also works with school children, speaking about the importance of finding and pursuing their life's work. "We all have passion in life," she said. "You just have to think in your heart 'what is the one thing you want to do,' and go for it." She is seen above in her Muriel's restaurant with cast members of *Amistad* when filming here in 1993, and at left with the late Charlie Berluti, famed *Newport Daily News* composing room foreman. (Courtesy of Muriel Barclay de Tolly.)

Betty Hutton

Born Betty June Thornburg, Hutton (1921–2007) starred in 20 feature films in the 1940s and 1950s, earning a Golden Globe nomination for her performance in the 1950 MGM musical *Annie Get Your Gun*. Performing since she was four, Hutton was dubbed "America's No. 1 Jitterbug" at age 18 for her dazzling nightclub performances and signed with Paramount at age 20. It was her drug rehabilitation, however, that brought her to Newport. She had been performing in Massachusetts, later recuperating in an alcohol facility there. Fr. Peter Maguire, of St. Anthony's Church in Portsmouth, was checking his cook into the same facility when Hutton saw him, and she said, "I'm going to meet that man. He's going to save my life." She moved to the rectory and for five years cooked, cleaned, and made beds while he nursed her back to health. "If I hadn't gotten (to Newport), I wouldn't have made it," she said in a 1978 *Good Morning America* interview. "They didn't expect me to be super great here. These people … took me into their homes, their little homes, and held me in their arms and … hugged me back to life." In the early 1980s, she stayed in the Pen Craig estate overlooking Newport Harbor while attending Salve Regina University, graduating with a master's degree in liberal studies in 1986, seen above right with Pres. Lucille McKillop. Newport was the ideal place for her rebirth, and she even hosted parties for close friends who had helped her along the way, including Salve philosophy professor James Hersh, whose own daughter Kristin had worked with Hutton (see page 106). In 1996, Father Maguire died, and Hutton moved to Palm Springs shortly thereafter. She is seen above left with her mother Mabel and sister Marion (right) in 1925. (Left, courtesy of the Betty Hutton Estate; right, courtesy of Salve Regina University, Newport, RI.)

Kay Worden

Petite bronze sculptures of young girls diving into a pool grace this artist's Jamestown home, but it is the gigantic wave with two feet sticking out that has garnered her so much attention. Installed in 1983 on America's Cup Avenue, the sculpture took a year to mold in clay and then cast in bronze, as does all her work. Despite its popularity among passersby who dress the feet in socks each winter, Worden (1925 to present) said it is not her favorite. "I just love that people have fun with it," she said. Others are displayed at Child & Family, where she is a trustee and volunteer; Newport Hospital; and Easton's Beach. She has sculpted nearly 60 since college. She came to Newport in the 1980s after living in Los Angeles with her late husband Fred and five children. (Above, courtesy of Kay Worden; below, photograph by Annie Sherman.)

John "Fud" Benson and Nick Benson

The father-son duo is continuing a tradition of hand-carving one-of-a-kind inscriptions in stone that has endured at their John Stevens Shop since 1705, where they create the original artwork in pencil and paint and then carve the gravestones, signs, and monoliths. It is one of the nation's oldest businesses, with the constant echo of hammer on chisel on slate emanating from the Thames Street space. Fud (1939 to present) has lost count of the number of times he has drawn the Roman alphabet, but "I never get tired of doing these simple little strokes," he said, paintbrush in hand. When Fud's father, artist John Howard Benson, bought the shop in 1927, he became only the second family to own it after the Stevenses. Though Fud studied sculpture and fine art at Rhode Island School of Design, he had apprenticed at the age of 15 to earn money, and although he has returned to sculpture after nearly 60 years of lettering, he still has an occasional hand in the old shop practices. The same destiny befell Nick (1964 to present) at 15 when his ability with the craft was undeniable. Nick took over in 1993 when Fud retired, and Fud now has a sculptor's studio behind the shop, close enough for Nick to seek occasional advice. Their roster of impressive commissions includes the National Gallery of Art, the Boston Public Library, and numerous memorial sites like those celebrating John F. Kennedy, Dr. Martin Luther King Jr., Franklin D. Roosevelt, and Vietnam War and World War II veterans.

Nick is sustaining the shop's, and the family's, prominence in an uncommon trade, winning a National Endowment for the Arts National Heritage Fellowship in 2007 and, in 2010, a MacArthur Foundation fellowship and "genius" grant, all of which he said justifies the painstaking work. "What we do, you can count on two hands the number of people doing it," Nick said. "But there is a connection people have to something done by hand. That is immensely satisfying to me." (Courtesy of Nick Benson.)

Richard Grosvenor

For 40 years, this well-known local artist inspired students to create beautiful paintings and design buildings as an art and architecture teacher at Middletown's St. George's School. He also taught his own four children. The passion to paint, teach, and create runs strong, because Grosvenor (1928 to present) continued all three passions when he retired from the school in 1992. "He was always painting," said his wife, Margot. "Even when we traveled, we looked for places that were interesting to paint." Known for his landscapes and coastal scenes, he founded the Spring Bull Gallery at the corner of Spring and Bull Streets as a studio, later welcoming other painters to paint and exhibit there, which they continue today. He also designed and built the family home, as well as several catamaran boats and an airplane. He is seen here painting in his studio in 1998. (Photograph by Kathryn Whitney Lucey.)

William Heydt

William Heydt (1949 to present) says it is not his intention to make people important by painting a watercolor portrait of them. He is just documenting the city he loves and the people who live here. But his prints of local businesspeople, athletes, artists, and legends hang all across town, while others clamor to be painted. Originally a photographer in his native New York City, the Rhode Island School of Design graduate started painting his friends' portraits from photographs when he moved here from Jamestown in 1999 with his wife, Rosemary, and their three children. The idea grew to include hundreds of portraits that he has since featured in his "Newportant" series of books and that have inspired a reality television series filmed in the city. Below is a sample of his watercolor work, modern people in a colonial setting. (Left, photograph by Ron Cowie, courtesy of *Newport Life Magazine*; below, courtesy of Bill Heydt.)

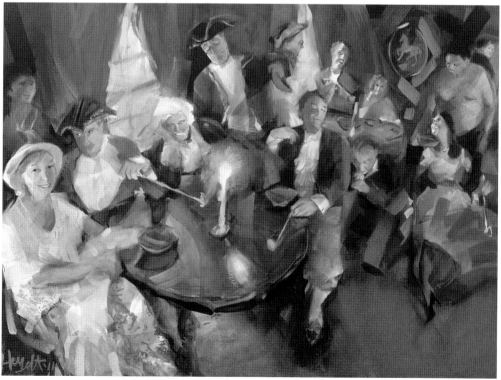

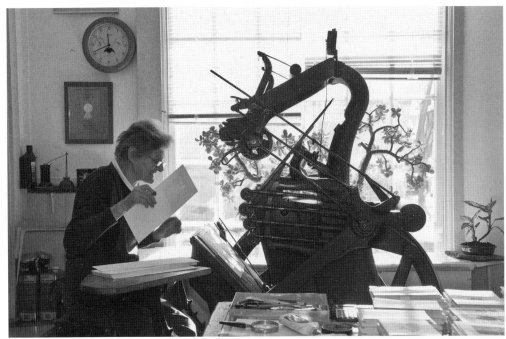

Ilse Buchert Nesbitt

Japanese art and decor, paper lanterns, and dozens of books fill Ilse Buchert Nesbitt's (1932 to present) living room on The Point, adjacent to the quaint studio and gallery where she has operated the Third and Elm Press since 1965. Born in Germany, she grew up in Japan during World War II; she later studied art, lettering, and typography in Frankfurt. She met calligrapher and typographer Alexander Nesbitt in 1960 when teaching at Rhode Island School of Design, where he was also a teacher; the pair moved to Newport to marry and open their printing shop. They made books, note paper, woodcuts, and art on their 19th-century cast-iron presses that she still uses today, printing with individual letters on pieces of handmade paper one at a time. Though Alexander died in 1995, Ilse still prints every day, as seen above. (Photographs by Sandy Nesbitt.)

Sandy Nesbitt and Rupert Nesbitt

Raised with a bookbindery in the kitchen, tools lining the walls, and no television, meant Ilse's sons, Sandy (1967 to present) and Rupert (1968 to present), learned to be crafty. "The living space is tangled with the workshop, so we grew up with raw materials everywhere," said Sandy. "It was very liberating. We could make whatever we wanted." He remembers making furniture and learning to melt lead over the stove with dad. Of course, the brothers became professional artists. Sandy studied engineering, sculpture, and photography and has become an internationally known photographer with a studio in Newport. This 2012 self-portrait, above, was taken there. Drawing since he was little, Rupert received a master's of fine arts degree in painting and now makes art reproductions in New York City. He also was an archeological illustrator for eight seasons in Egypt, painting artifacts that were unearthed, as seen below in 1999. (Photographs by Sandy Nesbitt.)

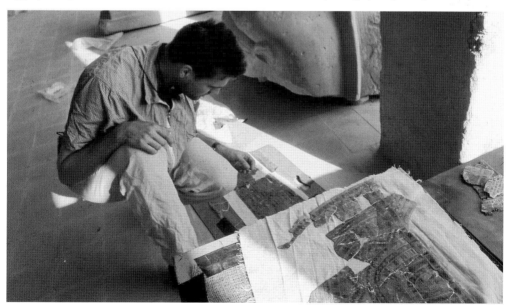

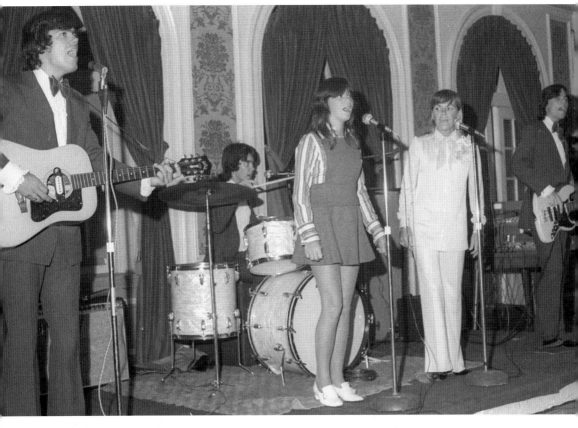

The Cowsills in Newport

Newport's Partridge family performed at school dances, churches, King Park and Bannister's Wharf in the 1960s before fame came knocking. The four brothers, Bill, Bob, Barry, and John Cowsill wanted to be The Beatles, recording their first album, *All I Really Want To Be Is Me* in 1965. They were signed briefly to Mercury Records thanks to a *Today Show* performance, before mom Barbara, sister Susan, and brother Paul joined. *The Rain, the Park and Other Things*, recorded in 1967 with MGM Records, became a No. 2 Billboard hit single in the United States, top 5 around the world, and skyrocketed the self-taught musicians to stardom. Another single, *Hair*, was the title song for the hit musical by the same name in 1968, though it was banned from Armed Services radio in Vietnam for being too controversial. They are performing here in Newport on July 16, 1971. (Courtesy of *The Newport Daily News*.)

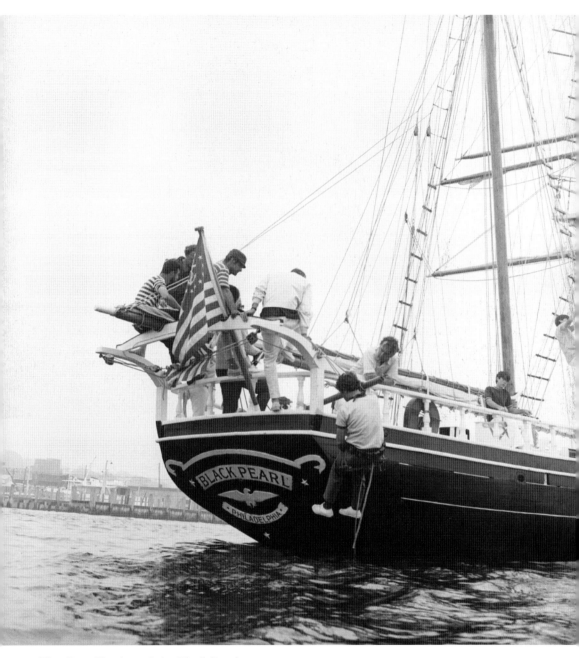

The Cowsills aboard the *Black Pearl*
Performing regularly on television variety shows, the Cowsills turned down an offer to film their own show, which ultimately became *The Partridge Family*. The Cowsills were the first to be awarded a multimillion-dollar celebrity endorsement contract, appearing in ads for the American Dairy Association. Some band members were Grammy Award presenters while still in grade school, and Susan was the youngest female to ever have a Top 10 hit, at the age of eight. They are cruising here aboard *Black Pearl* in Newport in 1968. By 1972, the band had gone their separate ways, but they have continued to record and play music across the country for the past 40 years. (Courtesy of *The Newport Daily News*.)

Throwing Muses

The band met while attending Cranston Calvert Elementary School, performed their first gig at the Newport Art Museum, and became one of the original 1980s alternative rock bands with hits on the UK charts. Singer-songwriter-guitarist Kristin Hersh, her stepsister and singer-songwriter-guitarist Tanya Donelly, drummer Dave Narcizo, and bassists Fred Abong and Leslie Langston signed to 4AD Records in 1986 and Warner Bros. in 1987, touring the United Kingdom, Europe, Australia, and New Zealand for nearly two decades. Known for their unorthodox song structures, surreal lyrics, and shifting tempos, they recorded seven albums since forming in 1980, despite some variations in band members. "We were described as being an 'acquired taste,'" said Narcizo (center), who still performs and owns a graphic design firm in Newport with wife, Misi. "We didn't think we were that weird, but I was still shocked when we got publicity." Hersh (left) splits her time between New Orleans and Newport, still writes and performs music with multiple bands, has written a book, and has performed with Narcizo and bassist Bernard Georges (right) as Throwing Muses for 20 years. "I strive to play the right music, regardless of who likes it," she said. "Substance over style doesn't always make you a lot of friends, but the ones you do make are loyal forever." (Photograph by Steve Gullick.)

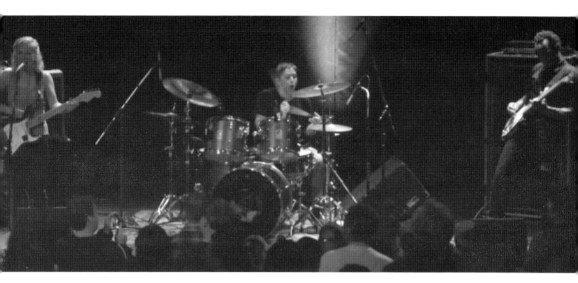

Throwing Muses Anthology

In 2011, the Throwing Muses trio Kristin Hersh, Dave Narcizo, and Bernard Georges released a two-disc musical anthology to celebrate their 25th anniversary, which is "neither an exhaustive box set nor a greatest hits collection," but rather "a mix tape personally compiled by the band," said Hersh on her website. Along with a multi-country tour and a book of lyrics and essays released in 2013, their continuing creativity in the musical realm reminds them they still rock. So does the album art, seen here, which Narcizo designed. "We were definitely a conspicuous part of the alt rock movement in the U.S.," said Narcizo, who taught himself the drums in order to play in the band and still performs regularly in Newport. "It was a really fun time to be doing what we were doing." (Courtesy of Dave Narcizo.)

George Wein

Wein (1925 to present) is synonymous with the Newport Jazz and Folk Festivals. Hired to produce what would become the first outdoor jazz festival in the country in 1954 by socialites Elaine Lorillard and her husband, Louis, this jazz legend is still producing the festival nearly 60 years later. He founded its sister folk festival in 1959 with the same persistent energies and big-name performers, like Bob Dylan and son Jakob, Joan Baez, Elvis Costello, and Bela Fleck. The festivals have bounced from venue to venue through their chaotic history, an indication of Wein's dedication to the art and the future of music in this small city. Though it started at the Newport Casino in

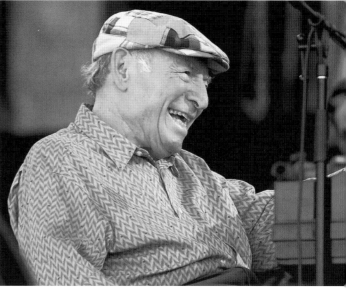

1954, the Lorillards bought Belcourt Castle (see page 54) specifically to house the festivals, as seen below in Belcourt's courtyard in 1955. By 1971, Festival Field was their home, but a riot of 10,000 spectators overran the stage and ended both festivals. Jazz fest resurfaced in 1981 at Fort Adams, with folk fest returning in 1985, both still attracting sell-out crowds at that waterfront venue today. Wein is still behind the scenes during every performance each summer. By 2010, Wein established the nonprofit Newport Festivals Foundation to perpetuate the history of jazz and folk music and to allow the festivals to live in perpetuity in Newport. An occasionally performing pianist (seen above at the 2008 Folk Festival), Wein said he is proud of the barriers that broke down and the musical forums that opened. "The best feeling for me?" he said in 2009. "It's the feeling you get at the end of a festival when you know you are coming back for another festival." (Above, photograph by Dave Hansen, courtesy of *The Newport Daily News;* below, courtesy of Harle Tinney.)

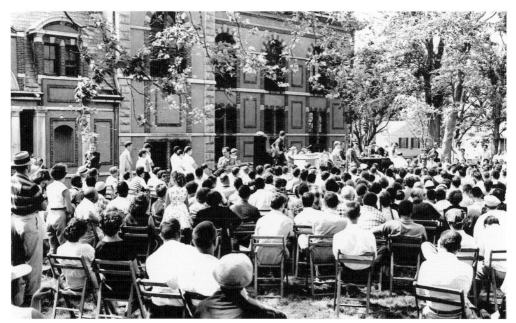

CHAPTER SEVEN

Philanthropy and Public Service

In Newport, making a difference in someone else's life is serious. It is also a vital resource. From mental health and affordable housing advocacy to lecturing on African American history, from community policing to helping fund some of the city's largest (and smallest) nonprofit organizations and events, philanthropists and public servants are devoted. They are also needed. Despite Newport's elaborate Gilded Age mansions and historic reputation for wealth, the city has one of the highest poverty rates in the state. So these public servants are battling more than just money issues; their passion and desire to serve has broad social impacts across the region.

Legendary local Pauline Perkins-Moye has been fighting for rights since she was young, marching on Washington, DC, for housing for the homeless, food stamps, and community action. Now, she directs the city's public housing office and teaches residents to use their voices and talents to seek a better life. Community police officer Jimmy Winters is a familiar face in the neighborhood, directing traffic in school zones and establishing the nation's first housing hotline in 1978. Tireless volunteer Myra Duvally organized a public tour of private Newport gardens twice annually since 1984 and donated every dollar raised, more than $1 million so far, to support arts, music, theater, and dance programs in local public schools. Philanthropist Noreen Stonor Drexel was dedicated to helping those who needed it most: the poor, the hungry, and the sick. Through her volunteer work at Newport Hospital, the Martin Luther King Jr. Community Center, United Nations, the American Red Cross, and other organizations, she advocated for substance abuse prevention, education reform, and public health care. These legends of civic duty, and others in this chapter, provide for their neighbors, lead by example, and speak up when the need is great.

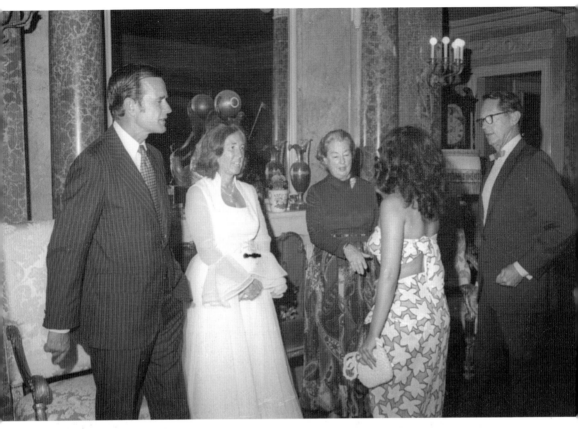

Eileen Slocum

A woman of wealth, manners, and strength, Slocum (1916–2008) was known as the "Grand Dame" of Newport, though she never called herself that. As a Republican national committeewoman, she and her late husband, John J. Slocum, were staunch supporters of the Grand Old Party for three decades, hosting political fundraisers at their Bellevue Avenue estate, including this one in 1973; she is seen wearing the white dress. In her *Newport Daily News* obituary, former Rhode Island governor Donald Carcieri said she was a great supporter of myriad charities, as well as "a trailblazer and a real role model for women in the political arena." Devoted to her three children, eleven grandchildren, and twenty great-grandchildren, her life was portrayed in the 2011 documentary *Behind the Hedgerow: Eileen Slocum and the Meaning of Newport Society*. (Courtesy of *The Newport Daily News*.)

Noreen Stonor Drexel

An incomparable humanitarian, Drexel (1922–2012) spent her life engaging in the most fundamental form of charity—helping the sick, the troubled, and the poor, one person at a time. Born in England, she came with her mother to the United States on the eve of World War II and was a descendant of the state's founder, Roger Williams. Through her life, she was dedicated to many charitable organizations, earning numerous community service awards and honorary degrees, including from Salve Regina University, where two buildings are named for her, and the Martin Luther King Jr. Community Center's Keeper of the Dream Award. She was a vocal sponsor of health care and public education, raising funds for Newport Hospital, and helping pass a bond issue for renovations to Thompson Middle School in 1999. An early activist for substance abuse prevention, she worked with local police to show youngsters the dangers of drug abuse. She even volunteered at the former Newport Naval Hospital as an ambulance driver and at Newport Hospital, where the birthing center now bears her name. She worked at the United Nations for several years, and thanks to her "broad outlook on humanitarian matters," she was appointed by the president of the American Red Cross to be the representative of the League of Red Cross Societies at the United Nations in the 1970s.

Known for her humility and grace, the former Noreen Stonor married John R. Drexel III, the scion of a powerful Philadelphia banking family. The couple was well known at society galas through the 1940s, 1950s, and 1960s and was married 66 years before he died in 2007. They had three children, seven grandchildren, and three great-grandchildren. (Photograph by Jacqueline Marque, courtesy of *The Newport Daily News*.)

Detective John J. "Okie" Connell
This Fifth Ward native and Hibernian was a 28-year veteran of the Newport Police Department. The driving force behind the nonprofit Police Relief Fund Association in 1984, which assisted families of deceased officers, and the now annual Newport Police Parade (below, second from left), Connell (1927–2009) was a steadfast devotee to his community, his wife, Jane, and their nine children. For all his good deeds, he remained modest, said his daughter Jane Full, and never expected thanks. "What he did for others was outstanding, he was so loyal and hard working," she said, remembering his big smile and friendly conversations with seniors while delivering food for Meals on Wheels. On top of his constant benevolence, he was also caretaker of Gooseberry Island for 25 years, and when he retired, directed security for Edgehill Rehabilitation Center. (Courtesy of Jane Full.)

James Winters

Encouraged to volunteer and help others at an early age, Winters (1941 to present) has become a familiar face here as a community police officer since 1981. But he is most proud of helping start the city's Housing Hotline in 1978, the first of its kind in the country. It has assisted more than 100,000 people find and maintain affordable housing on the island. Taking advantage of another talent, he helps fundraise through singing at benefit concerts as a volunteer with Volunteers in Service to America and the American Red Cross. He hopes to complete CDs of his inspirational music along with a script for a new movie about housing, once he establishes a temporary housing facility for the homeless. "Reach out and touch somebody's hand," he said. "Make this a better place if you can." (Photograph by Annie Sherman.)

Lt. William Fitzgerald

He has strayed very little from his roots, living in the same Fifth Ward neighborhood and remaining as dedicated to Little League as a Thompson Middle School coach as he was when playing. Now, he commands the Community and Traffic Services Unit for the Newport Police Department and was the second community police officer in the state when the program was implemented in 1989 in low-income neighborhoods. Fitzgerald (1957 to present) expanded it citywide, and it has become a model for the national program, he said. "It took a long time and a lot of effort," he said. "But we wanted to educate the public about what the police department does." His influence has spread across the city as well, and he advocates education as president of the DARE (Drugs Alcohol Resistance Education) program and Newport Community School. (Courtesy of William Fitzgerald.)

Jane Pickens

Born in Georgia, Pickens (1919–1992) led a charmed life, performing with her three sisters as the Pickens Sisters and then singing solo through the 1930s and 1940s. She performed with the New York Philharmonic and even had a daytime show on NBC. Her career faded in the 1950s, so she gave up the stage in 1954 and married her second of three husbands. Spending summers in Newport at her Bellevue Avenue estate, she became involved in numerous charities, including raising millions of dollars for United Cerebral Palsy Foundation. She retired to Newport where the Jane Pickens Theater, seen below when it was St. Joseph's Church in 1919, was named after her in 1974, when she and sister Patti gave a dedication concert. (Right, courtesy of Jane Pickens Theater and Event Center; below, courtesy of the Newport Historical Society.)

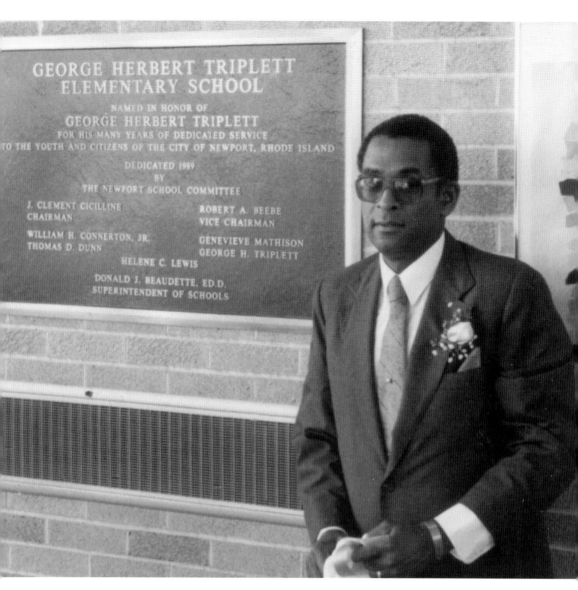

George Triplett

Known as "Flash" because he was born with a penchant for speed, Triplett (1937 to present) was a Rogers High School athlete and earned a track scholarship to the University of Rhode Island. "My mother always told us, 'No one ever promised you a rose garden. If you want something, you have to go out and get it,'" he said. And that he did. He worked at Sears, Roebuck & Company for more than 20 years and then at Newport Electric for another 20, retiring in 2000. He remained dedicated to education, devoting 16 years to the Newport School Committee, with four of them as chairman. In 1989, the George H. Triplett Elementary School was named in his honor; he is seen here at the dedication. Active in the community for 40 years, he coached Pop Warner and Little League and served on numerous advisory boards and committees, including the Newport Junior Chamber of Commerce. He earned the NAACP Role Model Award in 1997 and was Elks Lodge Citizen of the Year. (Courtesy of George Triplett.)

Frank E. Thompson
An educational visionary, Thompson (1849–1923) had an extensive impact on the public school system here. He was sub-master of Rogers High School for 17 years and then headmaster for 33 until 1923, when he retired a month before his death. Responsible for crafting the first professional standards for teachers in the state, his work led to the first teacher testing and certification system, and as chairman of the Rhode Island College of Education, he also helped develop curricula for the professional education and promotion of teachers. In addition to his administrative work, he continued to teach chemistry, physics, botany, and astronomy. *Newport Life Magazine*'s January 2000 issue reported the following tributes during his funeral that summarized his life and work: "His own sound scholarship and warm sympathy inspired scholarly aspiration and self-dependence," and, "Rarely does a man win the esteem and affection of an entire community as did Headmaster Thompson." Thompson Middle School is now named in his honor. (Courtesy of *Newport Life Magazine*.)

Florence Gray

Education was not only important to Gray (1923–2007); it was her life's mission to spread it. Growing up in the Kerry Hill neighborhood, Gray graduated from Rogers High School in 1941 and enrolled in Roger Williams College (now University) when she was 50, earning a bachelor's degree in 1975. She and her husband, Paul, raised three children in Tonomy Hill, where she became a vocal community activist for the underprivileged. As director of Project Head Start and, later, director of social services for Newport Housing Authority, she knew firsthand and fought the effects of low-income housing developments. Both buildings that house these organizations now bear her name because of her unflinching dedication and kind heart. "I had concerns for things that affect people, educated people to the powers that they have and the rights that they have," she was reported as saying in her *Newport Daily News* obituary. (Above, courtesy of *The Newport Daily News*; below, photograph by Annie Sherman.)

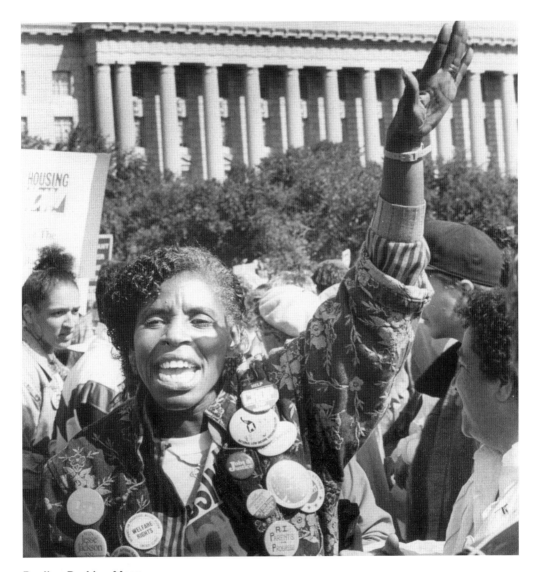

Pauline Perkins-Moye
There is no stopping Pauline. This proud advocate has been fighting all her life, for herself and others, starting when her Pearl Street house burned down when she was 11. She remembers so many people helping her family then when they needed it most that she dedicated her life to giving back. From marching in Washington, DC, for welfare rights in 1968, as seen here, and affordable housing in 1989, to working for Rhode Island Community Action for 25 years, Perkins-Moye (1941 to present) is a fighter. Now, as director of resident services at Newport Housing Authority, she educates people on their rights and individual work potential, organizing job fairs and offering assistance. This good cook even wants to teach young mothers how to prepare fresh food instead of relying on expensive ready-made meals. Also inspired by her mother, grandmother, and great-grandmother, all of whom worked themselves to the bone every day of their lives, she said, she is motivated to do the same, to beat the doom-and-gloom mentality that can often permeate the less fortunate. "My grandmother always used to say, 'Nothing beats a failure but a try,'" Perkins-Moye said from her Park Holm office where photographs of family and activist events she participated in line the shelves and walls. "But I don't do these things to reap the rewards. I appreciate that people appreciate what I do, but I'm very humbled by it." (Courtesy of Pauline Perkins-Moye.)

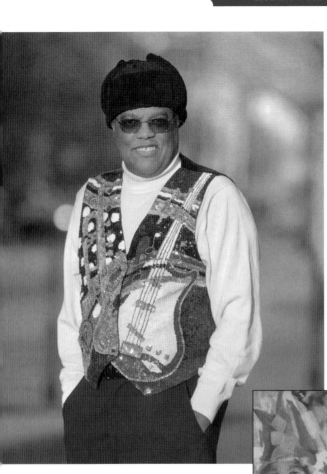

Charles Roberts

This fourth-generation Newporter spent three decades in the New York music industry working as an independent promoter with artists like Luther Vandross, Gladys Knight, and Chaka Khan. Now as the director of First Night Newport New Year's Eve celebration, Roberts's efforts are about bringing families of all cultures together. "I'm from the old school. I believe in Martin Luther King's philosophy of serving your community," he said. "That's something I learned from my aunt, Eleanor Keys." (See page 121.) Roberts (1945 to present) ran First Night from 2003 until 2009, when a blizzard deterred crowds and funding disappeared. While he works for its revival, he continues to produce musical concerts and cultural and children's events, and exhibits his artwork. (Left, photograph by Jacqueline Marque, courtesy of *The Newport Daily News*; below, painting by William Heydt.)

Eleanor Keys

The matron of African American history here, Keys (1924–2012) was the first draftswoman at the Naval Torpedo Station and continued working at the Naval Underwater Systems Center for 30 years at a time when it was rare to find a woman in that line of work, especially an African American woman. Known as Snooks to family and friends, she once said that a man told her that he had never worked with a woman before. She replied, "I told him that if he respected me as I respect myself, we would have no problem." She was a crusader her whole life, advocating for equal employment opportunities and pride in African American history, visiting schools, civic groups, and churches to educate people on the importance of recognizing their roots. She inspired family too, including cousin Paul Gaines (see page 70) and nephew Charles Roberts (opposite page). Even after her retirement in 1986, her February calendar was full of speaking engagements to honor Black History Month. As a result of her activism, she was awarded a mantle full of honors, including the George T. Downing Award, Rhode Island Black Heritage Lifetime Achievement Award, and the City of Newport Medal of Honor, and was the first to win the *Newport Daily News* Community Service Award when it was begun in 1996. "I was very pleased and very humbled," Keys said in 2002 when she won another accolade, Rhode Island's Living the Dream Award at the state's Dr. Martin Luther King Jr. Day ceremonies at the statehouse. "It makes me feel very good, especially when I know my work touches young people." Her own roots in Newport started with her father Louis Walker, who ran an independent cab and limousine company that her late husband, John, continued. She and John are shown here in 1996. (Courtesy of Paul Gaines.)

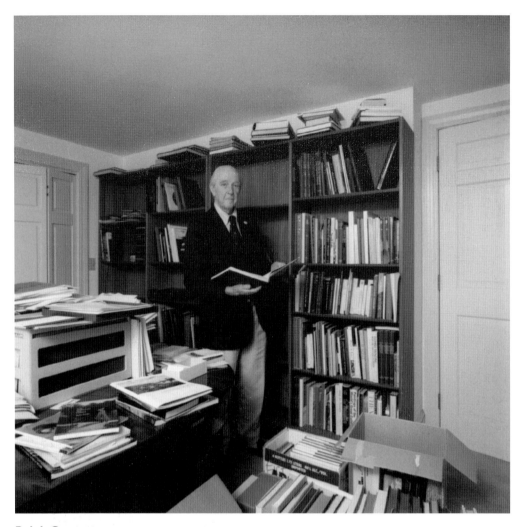

Ralph Carpenter

A financier and pension expert on Wall Street and later a decorative arts consultant with Christie's auction house, Carpenter (1911–2009) used his extensive finance and arts experience to preserve significant colonial architecture in Newport. Collaborating with the then nascent Preservation Society of Newport County, he worked diligently to preserve Hunter House and the White Horse Tavern, as well as Trinity Church, Redwood Library and Athenaeum, and Brick Market. "I have a tremendous love of Newport," Carpenter said in 2001, reported in his *Newport Daily News* obituary. "And I think it's amazing how many people feel passionately about Newport." In 1953, he wrote and published *The Arts and Crafts of Newport, Rhode Island, 1640–1820*. As chairman of Redwood's Restoration Committee in 1993, he helped devise a plan to restore and expand the library, a project that was completed in 2006. He even donated 1,300 books and 25 linear feet of documents to Redwood, which came from his own library, seen here, and which are now in its Carpenter Room. "He was ahead of his time in terms of focusing on historic houses and preservation activity," Redwood's former executive director Cheryl Helms said when he died. "He actively promoted the idea these homes should be protected for future generations way before the concept of cultural tourism was developed." (Courtesy of the Redwood Library and Athenaeum.)

J. Clement "Bud" Cicilline

His first visit to the state house when he was five helped solidify a political career before his first campaign was even a twinkle in his eye. But this Providence native is now known for more than just dedicating 12 years to Newport School Committee and 10 as state senator. Cicilline (1940 to present) came here in 1968 as a clinical psychologist for the Newport County Mental Health Clinic, and while helping reduce psychiatric hospitalizations from 3,000 to 150, he helped expand the clinic to become the state's first comprehensive, federally-funded community mental health center, with headquarters in Middletown. He also taught at Community College of Rhode Island for nearly 30 years, volunteered with the Newport Democratic City Committee, Newport Festa Italiana, the Prisoner Reentry Program, and the McKinney Shelter. "I am proud to have been able to provide service to the community," he said, "because I believe the meaning and purpose of life is to understand and help one another." (Courtesy of Bud Cicilline.)

Myra Horgan Duvally

Philanthropy and the arts were in Duvally's blood. Born in Newport, she grew up in Fall River, Massachusetts, and moved back here after attending Wheeler School in Providence and Finch College in New York. Dedicated to her charitable life, Duvally (1926–2011) helped create the Newport Music Festival and the Benefactors of the Arts in 1984. Under this organization, her semiannual Secret Garden Tours raised $1.2 million for art and music education in local public schools. "I think it's a good thing to do for kids," Duvally said in 2008 when she won the *Newport Daily News* Community Service Award. "It gives them opportunities. All we hear now is about the conditions of schools and programs being cut. It's nice to be able to provide something." (Courtesy of *The Newport Daily News.*)

Adelaide "Ade" de Bethune

Born a Belgian Baroness, Bethune (1914–2002) emigrated here after World War II with her parents. She later became an internationally renowned Catholic liturgical artist, using her artwork and illustrations to help improve quality of life for the Catholic worker. In the 1960s, she was artistic director of the Terra Sancta Guild, a commercial firm that produced religious artworks for Christian organizations. Also active in providing hospitality for the poor and elderly, in 1969, she founded the Church Community Housing Corporation to secure housing for this demographic. She also founded Star of the Sea in 1991, a community of like-minded social, political, and religious people, which renovated a former convent into state-of-the-art elderly housing, where she lived until her death. (Courtesy of *The Newport Daily News*.)

BIBLIOGRAPHY

Booher, Bridget. "Ahead of Her Time." *Duke* magazine, Jan.–Feb. 2011: 26–31.

"The Cover." *Massachusetts Physician* magazine, February 1972.

Desautel, Parnel, and Philip Dickinson. "Art and Engineering: John Goddard and the Ogee Foot." *Newport History: Bulletin of the Newport Historical Society* vol. 66, (Fall 1994): 79–91.

Grinnell, Nancy Whipple. "Carrying the Torch in Newport: The Arts Advocacy of Maud Howe Elliott." *Newport History: Journal of the Newport Historical Society*, (Spring 2005): 1–30.

International Tennis Hall of Fame & Museum. *Tennis and the Newport Casino*. Charleston, SC: Arcadia Publishing, 2011.

Jeffreys, C.P.B. *Newport: A Short History*. Newport, RI: Newport Historical Society, 1992.

Lucey, Kathryn Whitney. *Born Newporters*. Pawtucket, RI: Quebecor World, 2002.

The Newport Daily News. Newport, RI: Edward A. Sherman Publishing Co., 2001–2013.

Newport Life Magazine. Newport, RI: Edward A. Sherman Publishing Co., 1993–2012.

Panaggio, Leonard J. *Portrait of Newport*. Newport, RI: The Savings Bank of Newport, 1969.

Snow, Edward Rowe. *Pirates and Buccaneers of the Atlantic Coast*. Beverly, MA: Commonwealth Editions, 2004.

Stensrud, Rockwell. *A Lively Experiment: Newport, Rhode Island 1639–1969*. Newport, RI: Redwood Library and Athenaeum, 2006.

Stinson, Brian. *Newport Notables*. Newport, RI: Redwood Library and Athenaeum, 2004.

Warburton, Eileen. *In Living Memory: A Chronicle of Newport, Rhode Island, 1888–1988*. Newport, RI: Newport Savings and Loan Association/Island Trust Company, 1988.

Youngken, Richard C. *African Americans in Newport: An Introduction to the Heritage of African Americans in Newport, Rhode Island, 1700–1945*. Newport, RI: Rhode Island Historical Preservation & Heritage Commission/Rhode Island Black Heritage Society, 1998.

INDEX

Find more books like this at
www.legendarylocals.com

Discover more local and regional history books at
www.arcadiapublishing.com

Consistent with our mission to preserve history on a local level, this book was printed in South Carolina on American-made paper and manufactured entirely in the United States. Products carrying the accredited Forest Stewardship Council (FSC) label are printed on 100 percent FSC-certified paper.

MADE IN THE USA